Sugary Dreams: A Sweet and Dessert Themed Coloring Book

Copyright © 2017 Yasmeen Eldahan, All rights reserved
yampuff.com

Cover and Book design by Yasmeen Eldahan

ISBN-13: 978-1537057064

ISBN-10: 1537057065

This book is for personal, non-commercial use only. While you are welcome to share pictures of this book and your colorings online, you may not take pictures, copies or scans of blank (uncolored) pages to sell or give away without prior consent from the author. When sharing online, please credit me, with a link to my page and/or with the tag #YAMPUFF

Thank you!

Following your dreams can be a funny thing
Everyone tells you to follow them,
but they never warn you that they change over time
I had a dream of being a novelist or a comic book illustrator or a food blog author
And I gave them all a try but none were the perfect fit
Then I found a passion for making coloring books

So this book is dedicated to following your dreams
Wherever they may take you
and in whatever strange form they might take

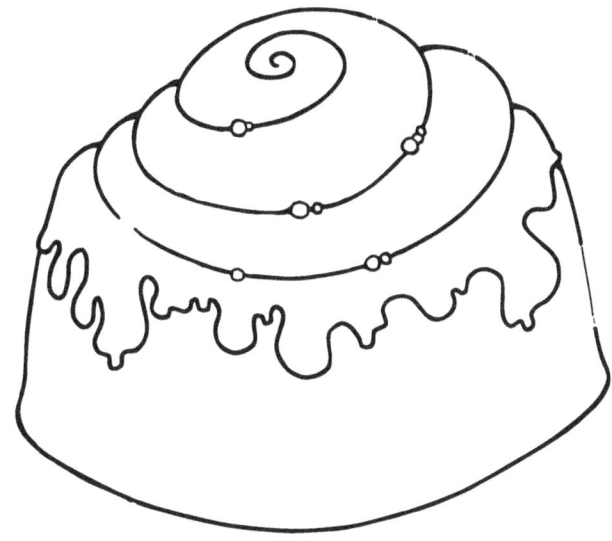

Connect With Me:
yampuff.com

Check out my art, coloring contests, free linearts, and more:

- **t** halfbakedyams.tumblr.com/
- **f** facebook.com/YamPuff
- **📷** instagram.com/halfbakedyams/
- **🐦** twitter.com/HalfBakedYams
- **P** pinterest.com/yampuff/
- **dA** yampuff.deviantart.com/

Or check out my shops for digital stamps, stickers and other merch:

- **E** etsy.com/shop/YamPuffsStuff
- **RB** redbubble.com/people/yampuff/shop
- **Z** zazzle.com/yampuff

How to Use This Book:

When coloring, I recomend for you to place a thick and/or bleedproof piece of paper behind the page you are coloring. This will prevent any color from leaking onto the subsequent pages and also save them from getting any dents or marks. The pages are all single-sided so you can use a variety of mediums freely. Crayons, gel pens, colored pencils, alcohol-based markers, regular markers, and more will all work!

Happy coloring!
-YamPuff

Welcome!

I'm YamPuff and I would like to welcome you to my latest coloring book; Sugary Dreams!
I do hope you like it - it's chock full of goodies and delicious treats!

Donut Madness

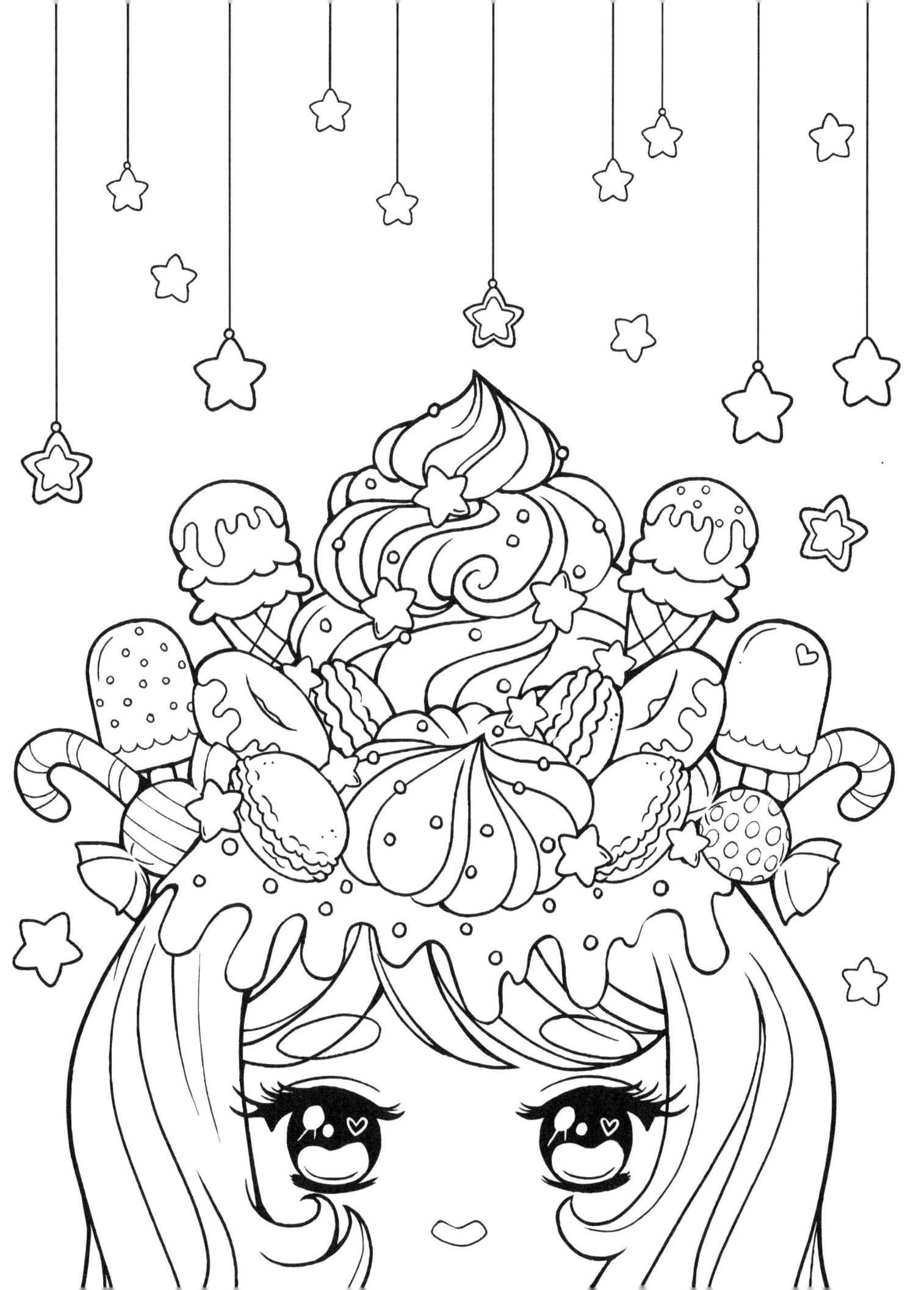

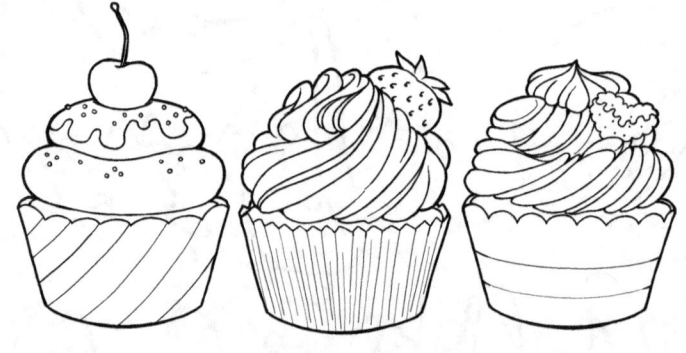

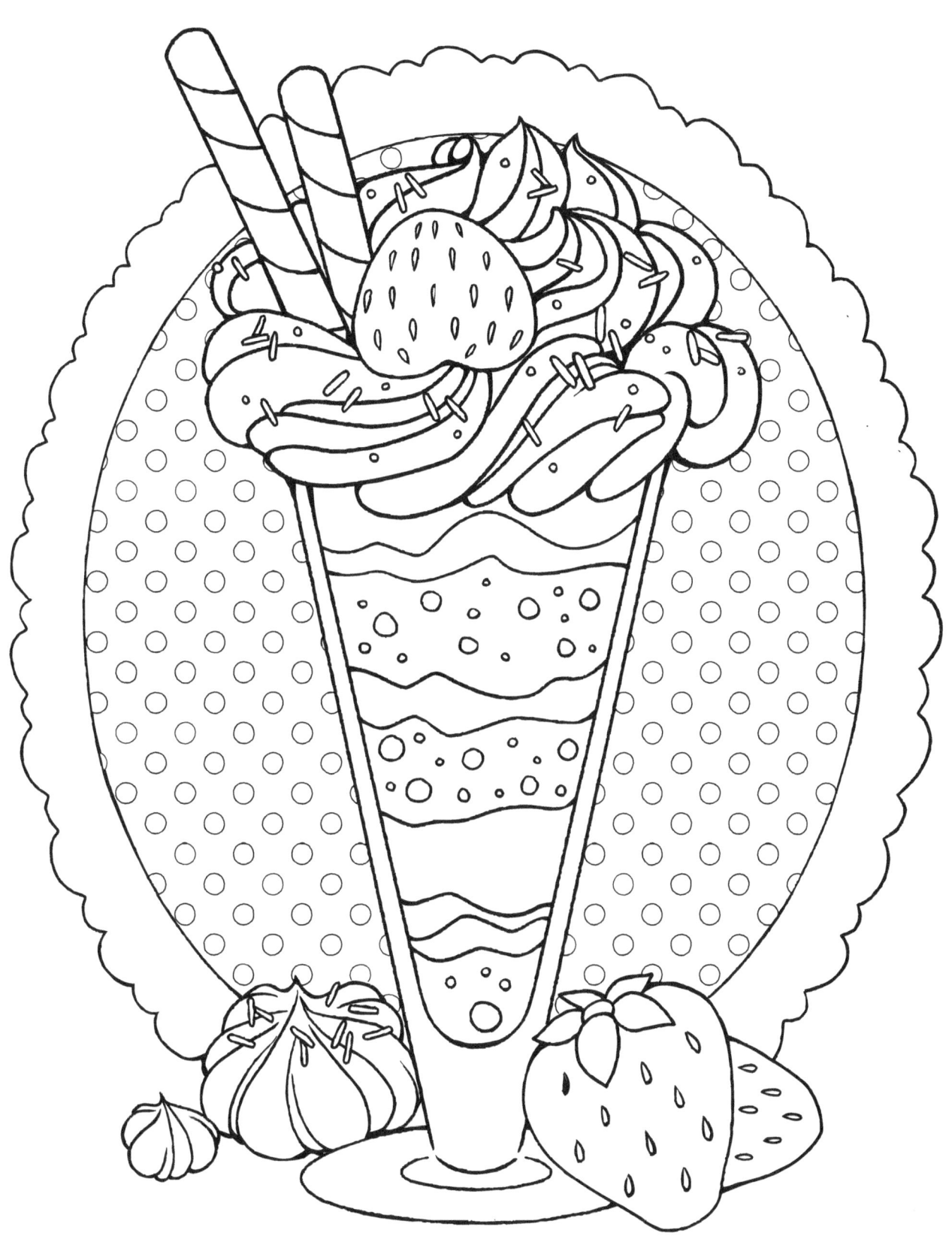

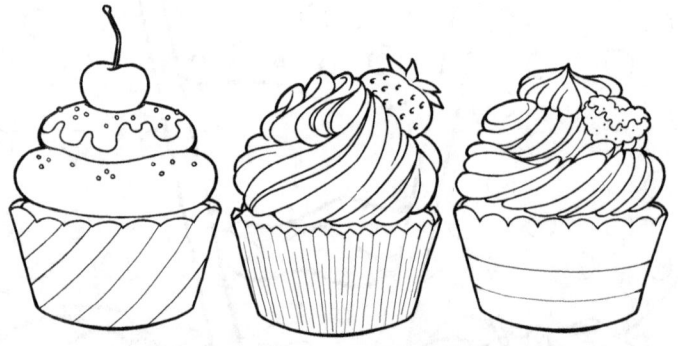

Sweet Strawberry Parfait

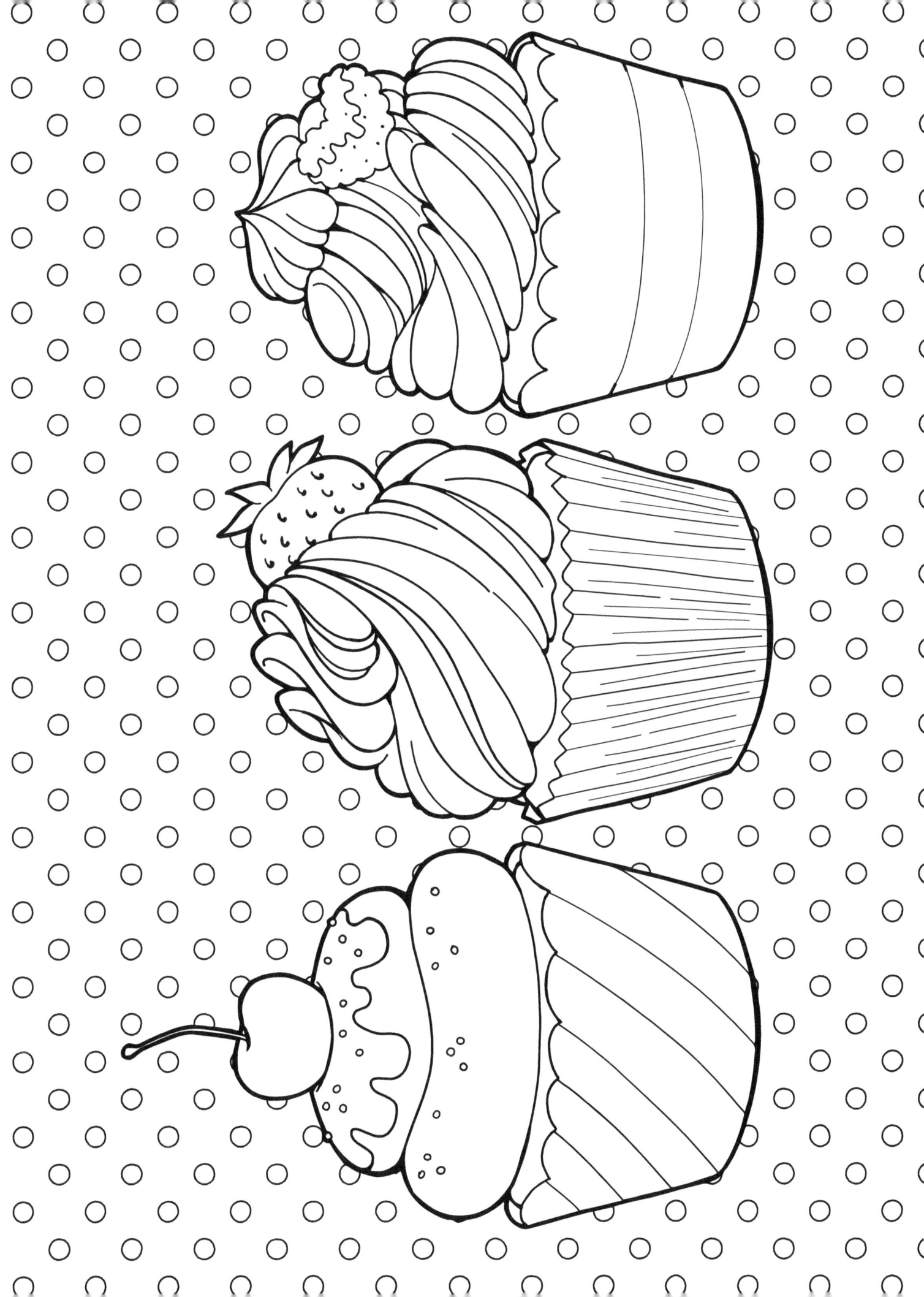

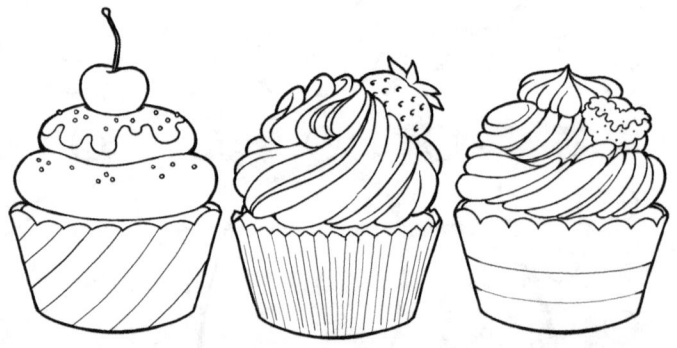

A Selection of Delicious Cupcakes

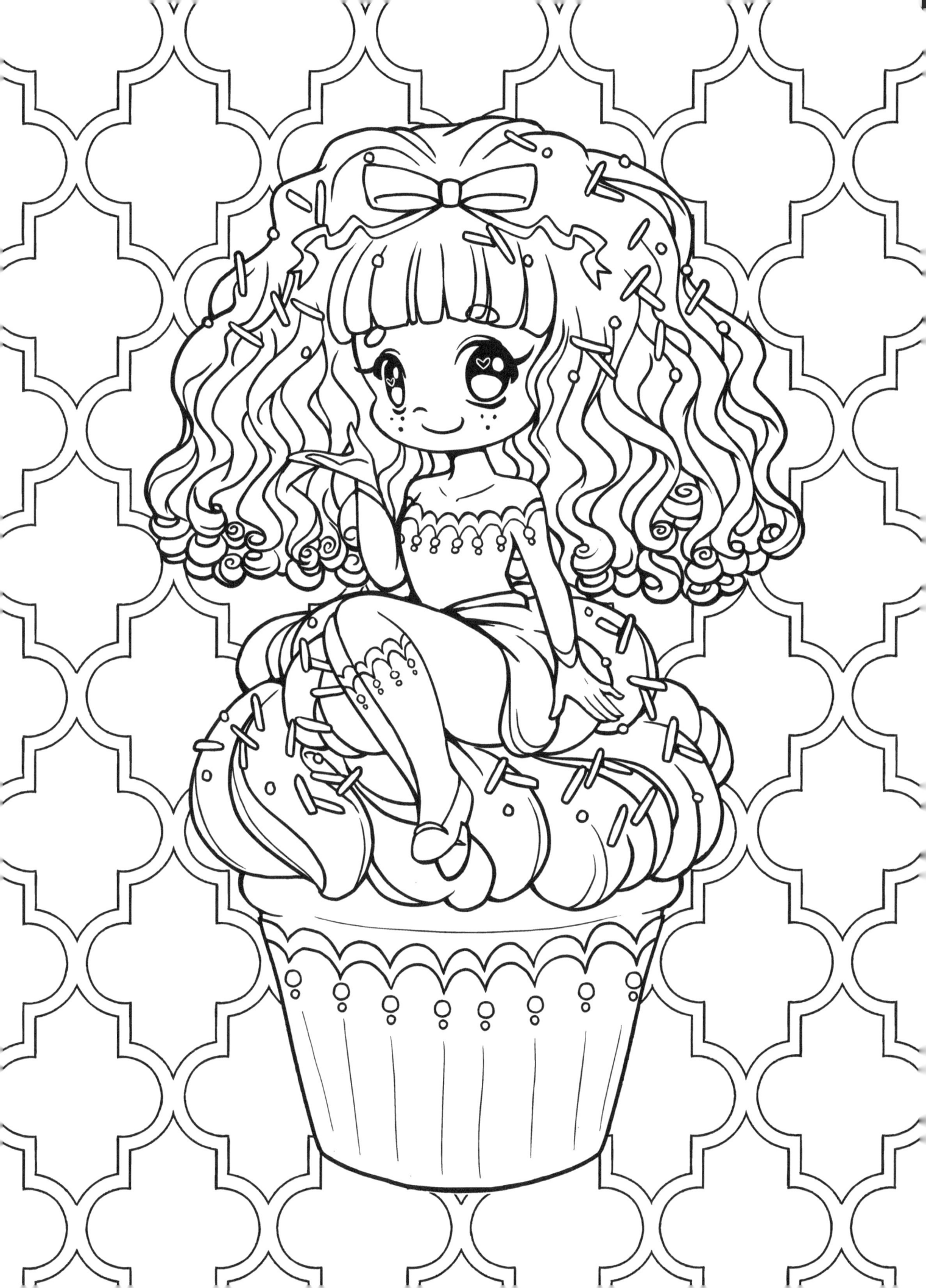

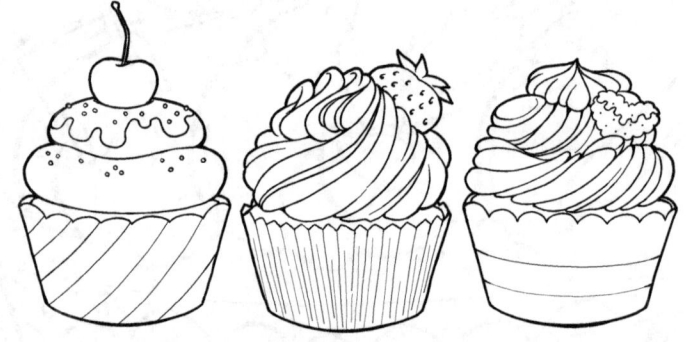

Cupcake Cutie!

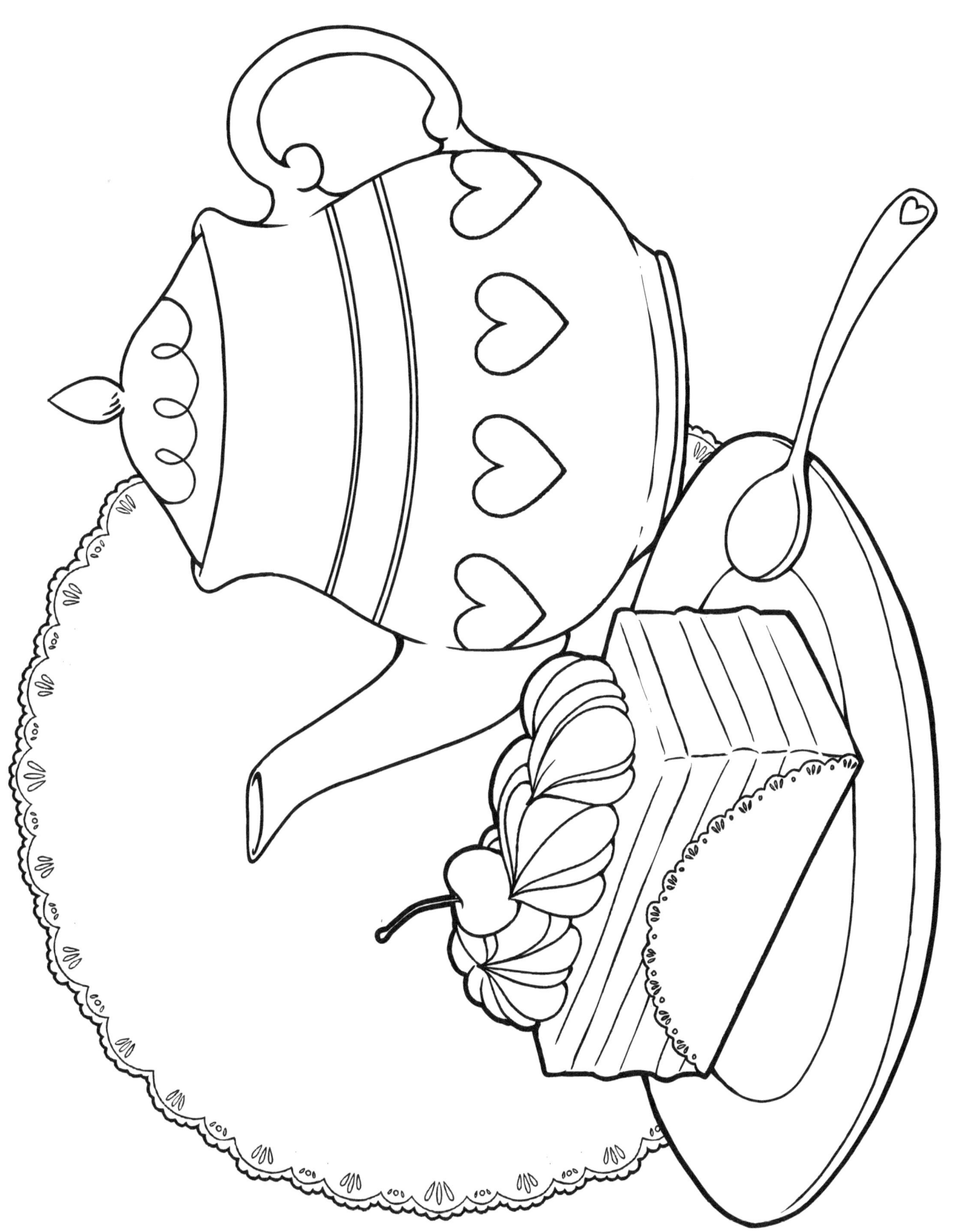

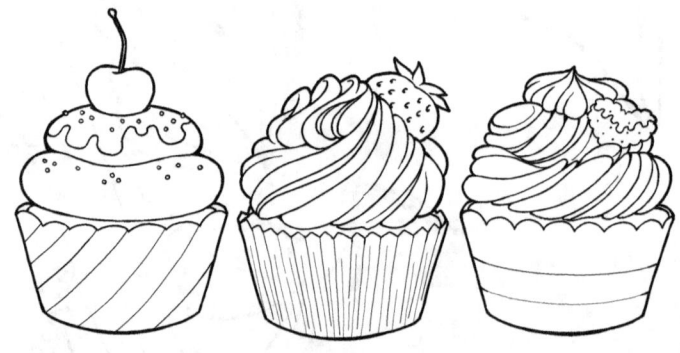

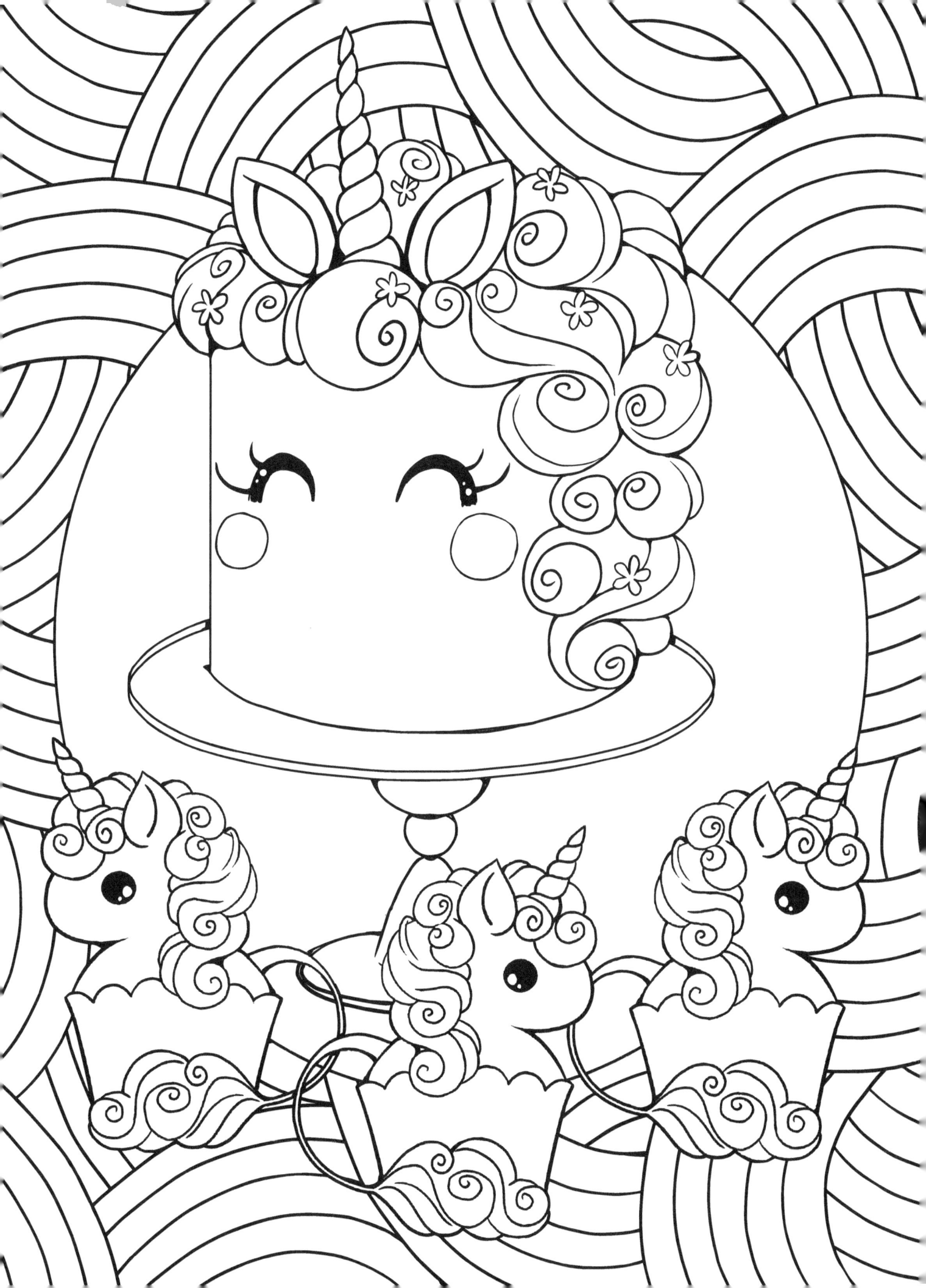

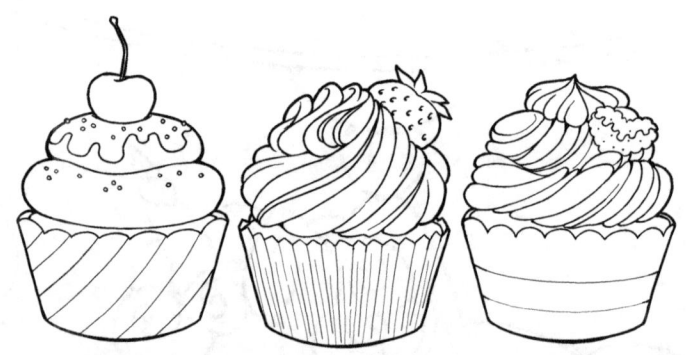

Unicorn Cake and Cupcakes

I came up with my pony cupcake design a long time ago, and was planning to include some in this book. While making an inspiratio board on Pinterest for Sugary Dreams, I found out about unicorn cakes! I knew I had to draw one with some cupcake babies!

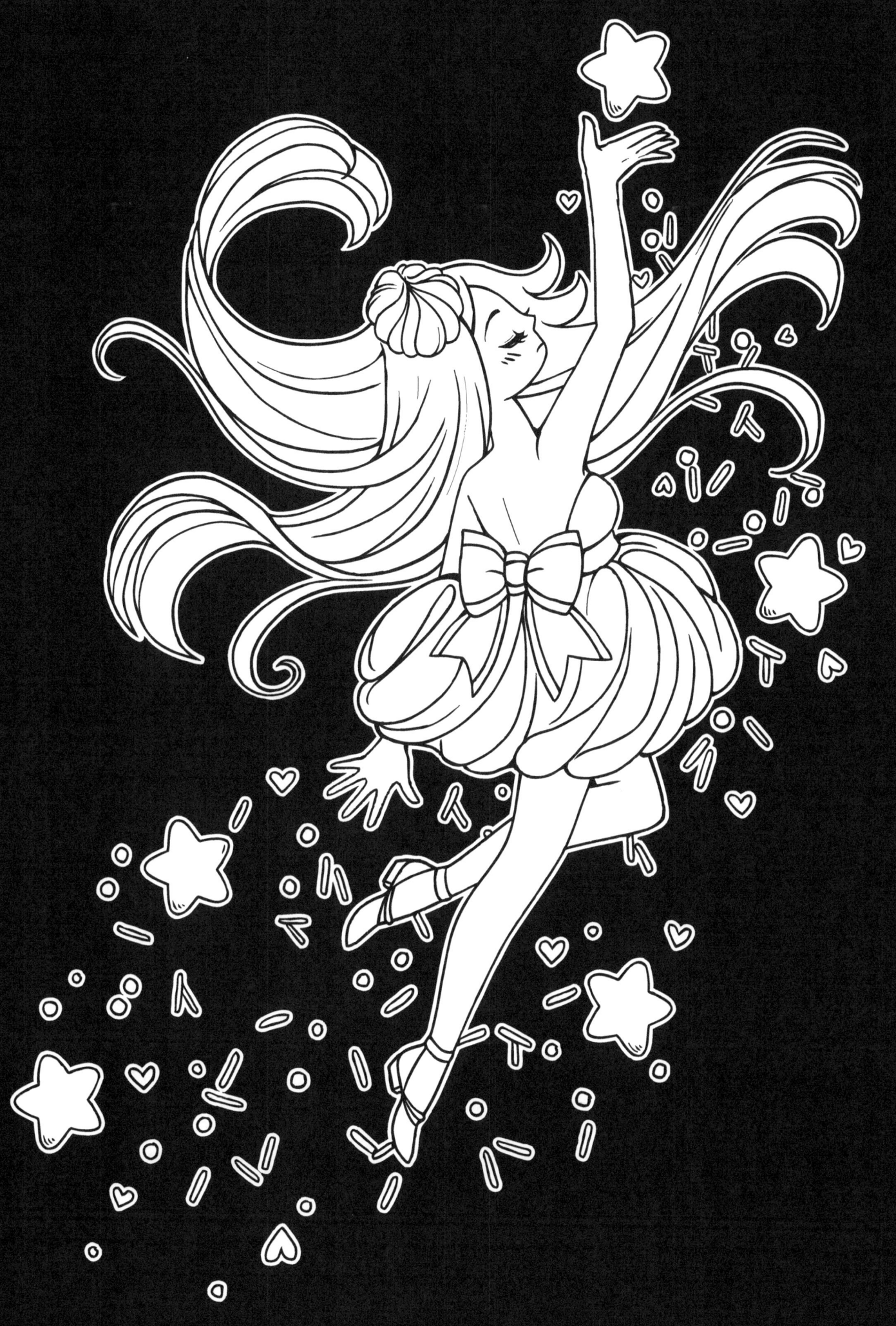

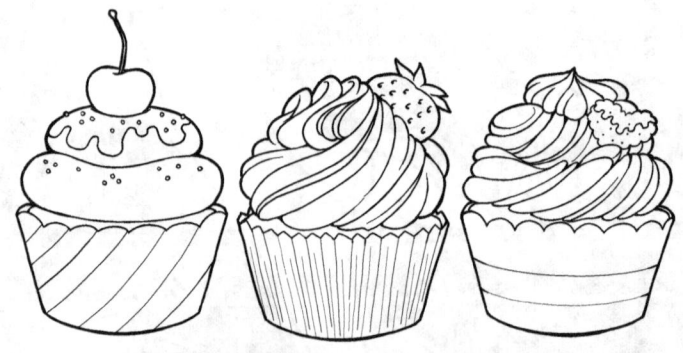

The Frosting Faerie

I drew the initial sketch for my Frosting Faerie during a break at work. I was thinking about Magical Girls at the time. I was inspired by coloring books featuring solid black bakgrounds so I included some in this book. I hope you like them! Try drawing over them with opaque and/or metallic pens!

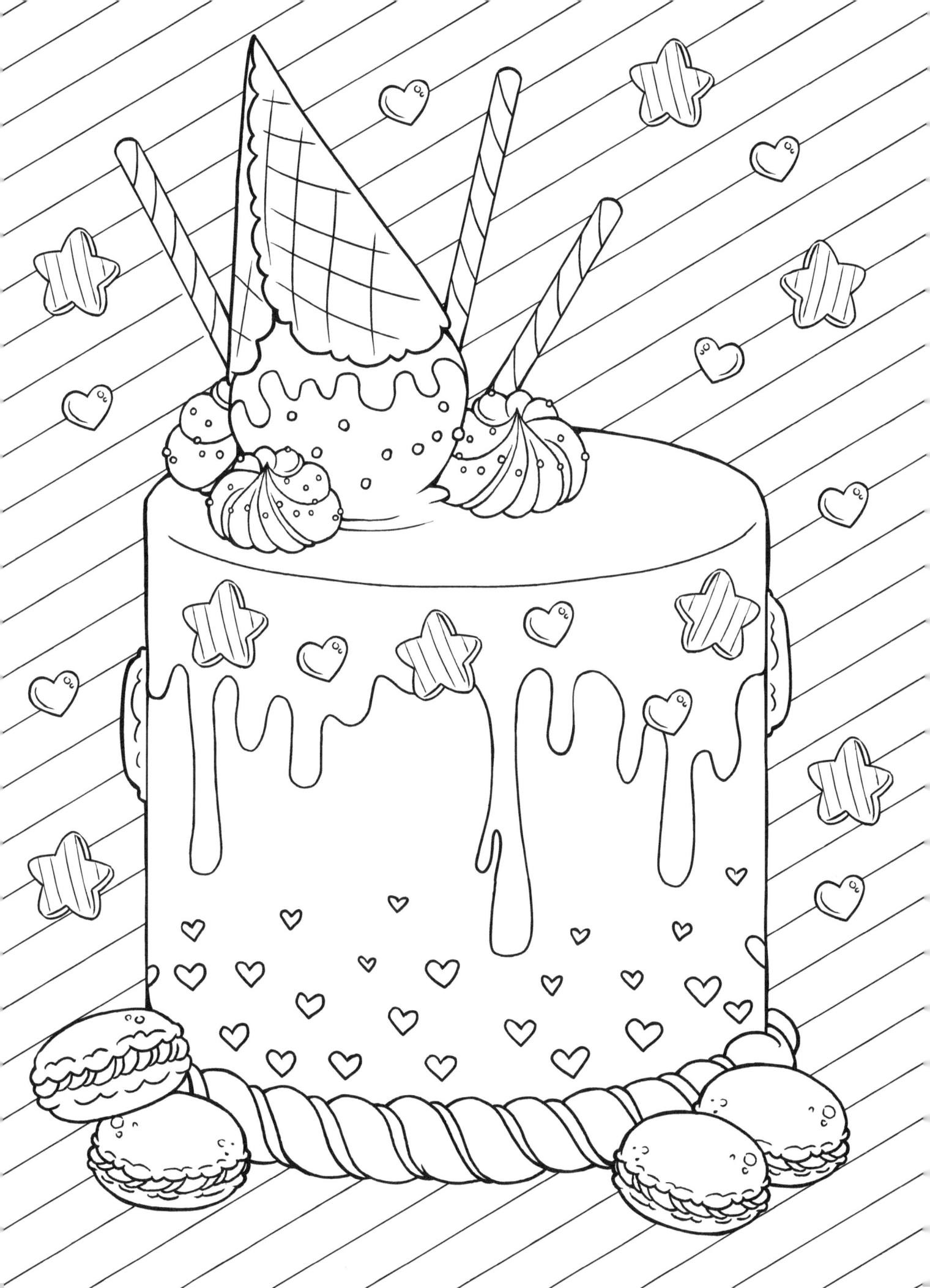

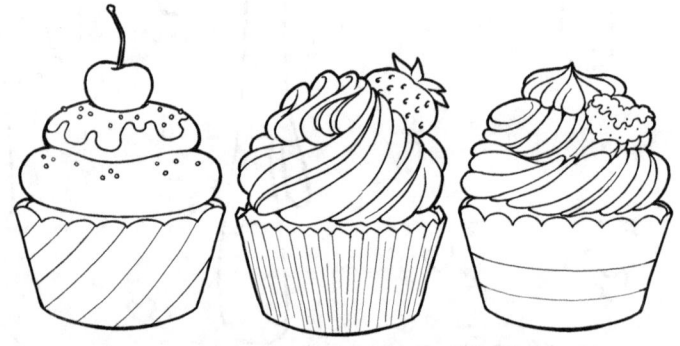

Fantastic Drip Cake

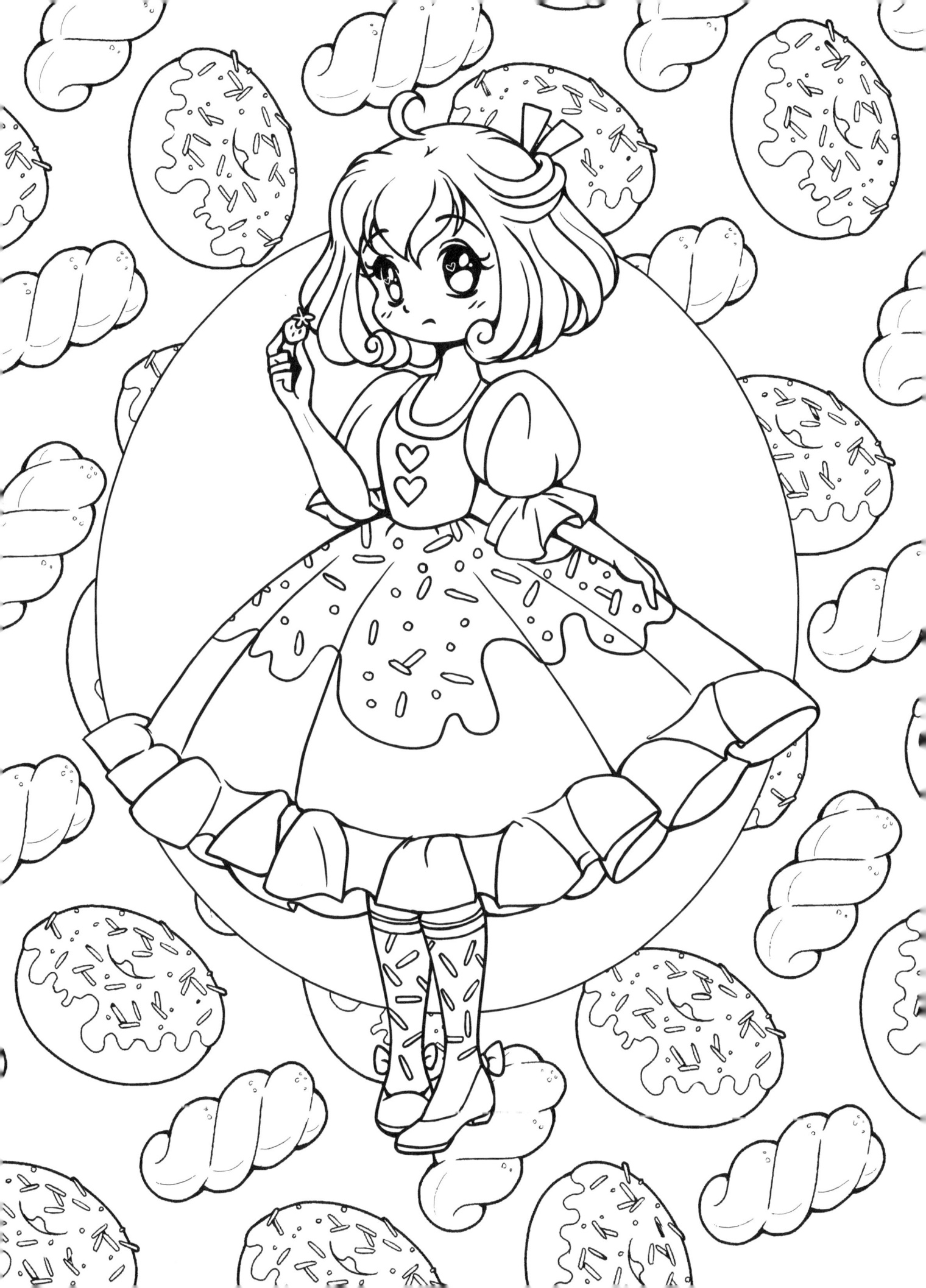

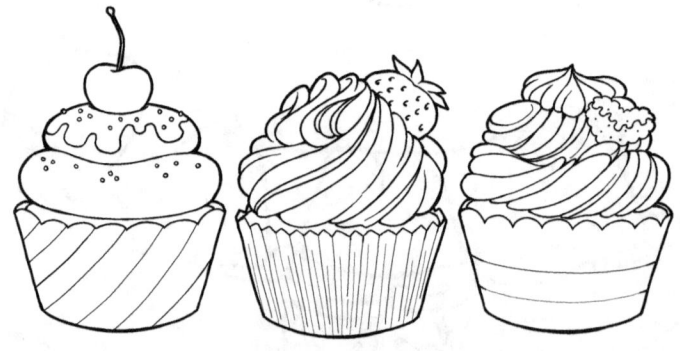

Sweet Donut Lolita

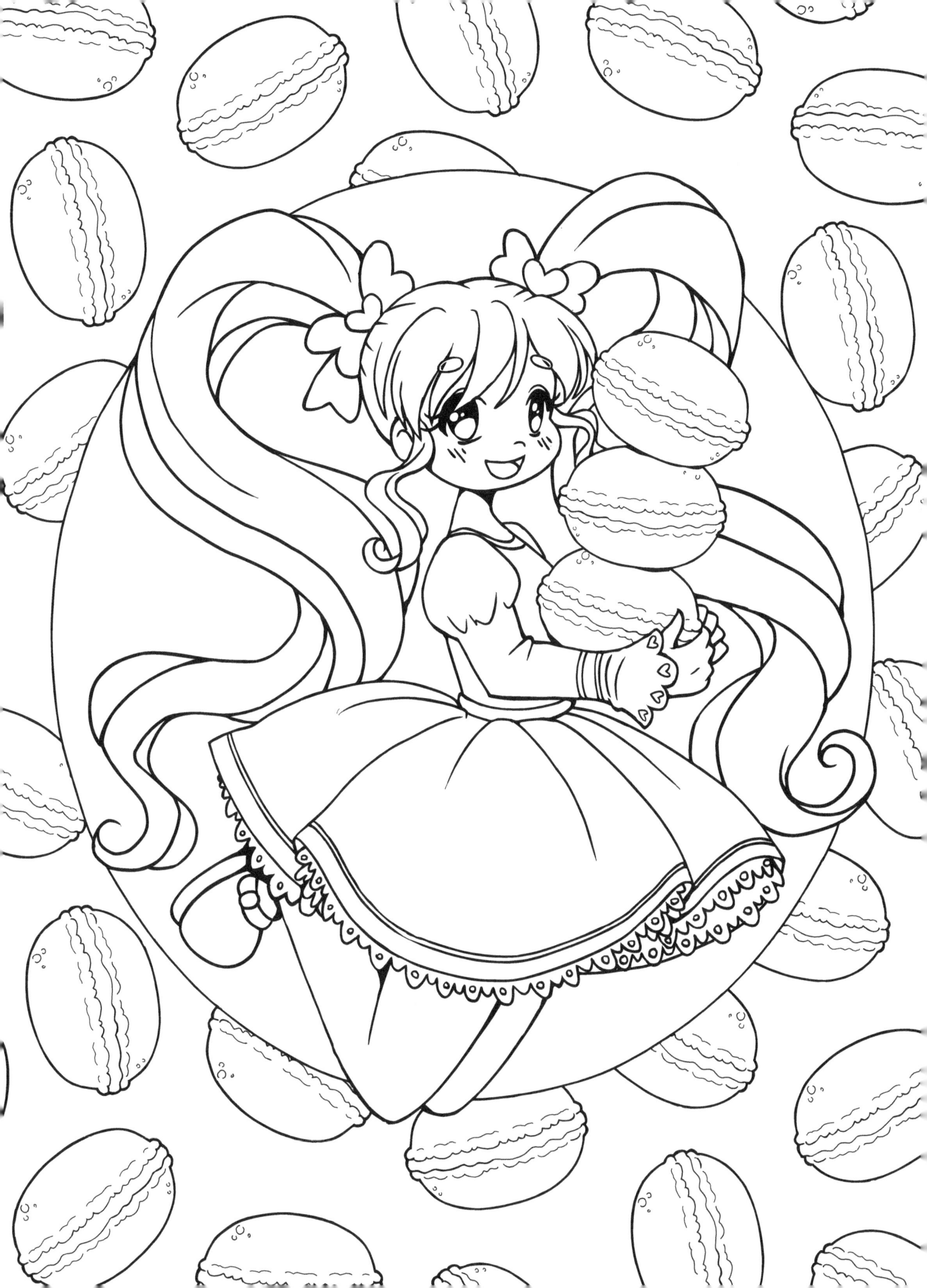

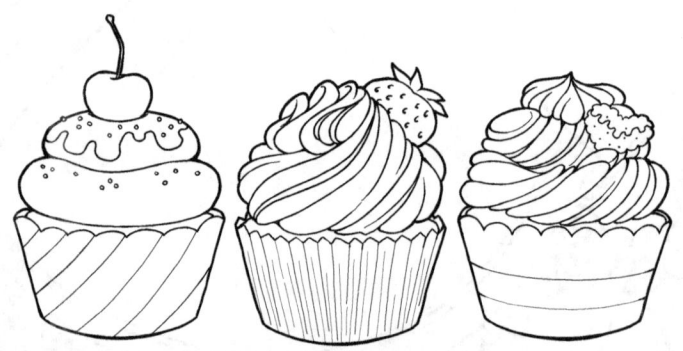

Macaron Rain

This was originally drawn as one of my 2016 Inktober works. She fit the theme of Sugary Dreams so well, I decided to clean up the original and add her in!

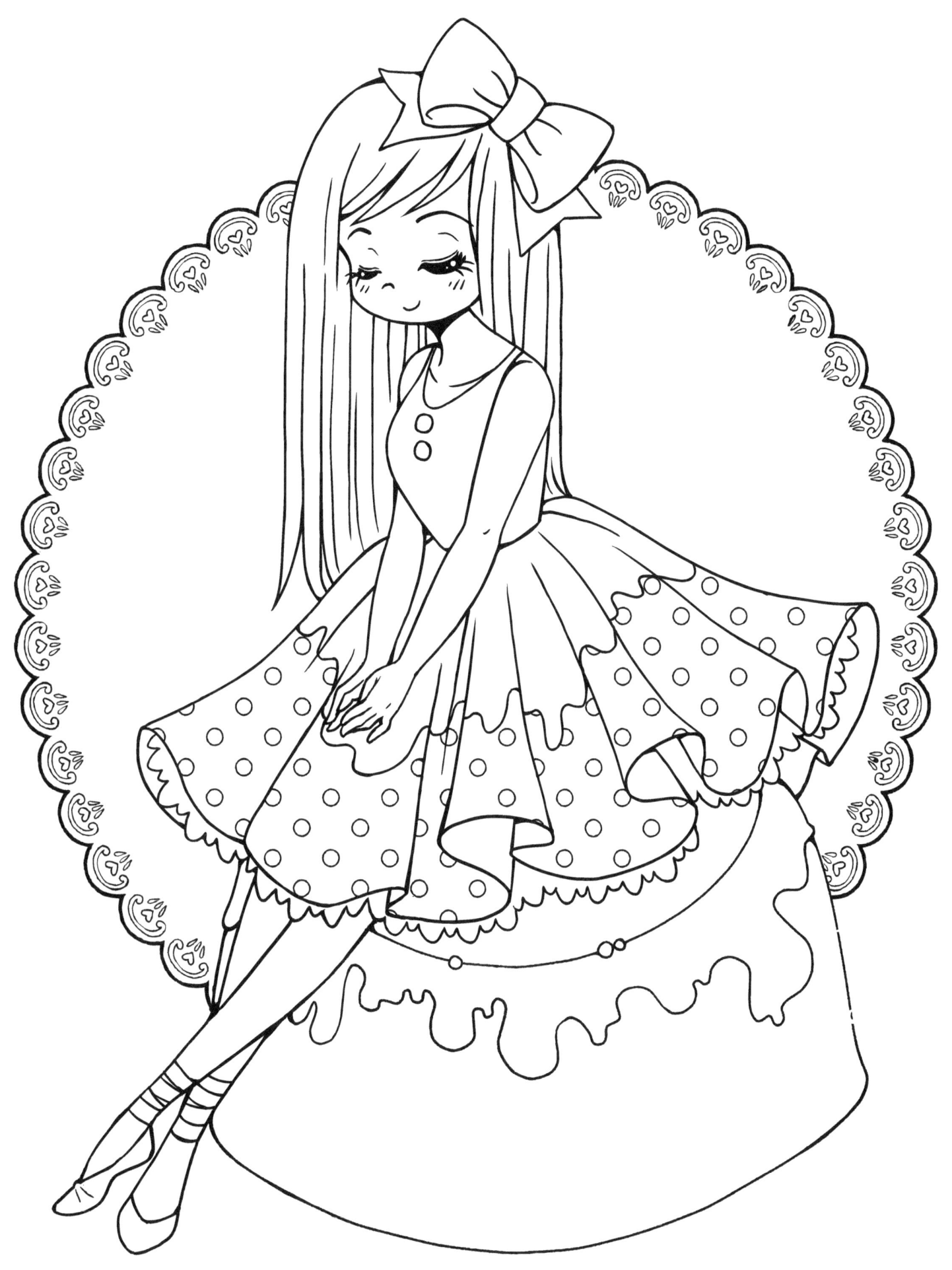

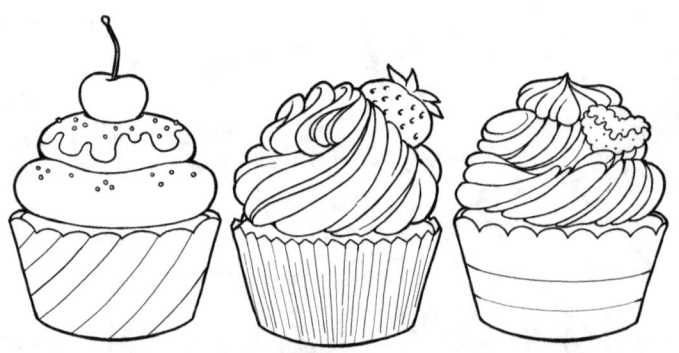

Little Miss Cinnamon Roll

Wouldn't the frosting get all over her skirts?

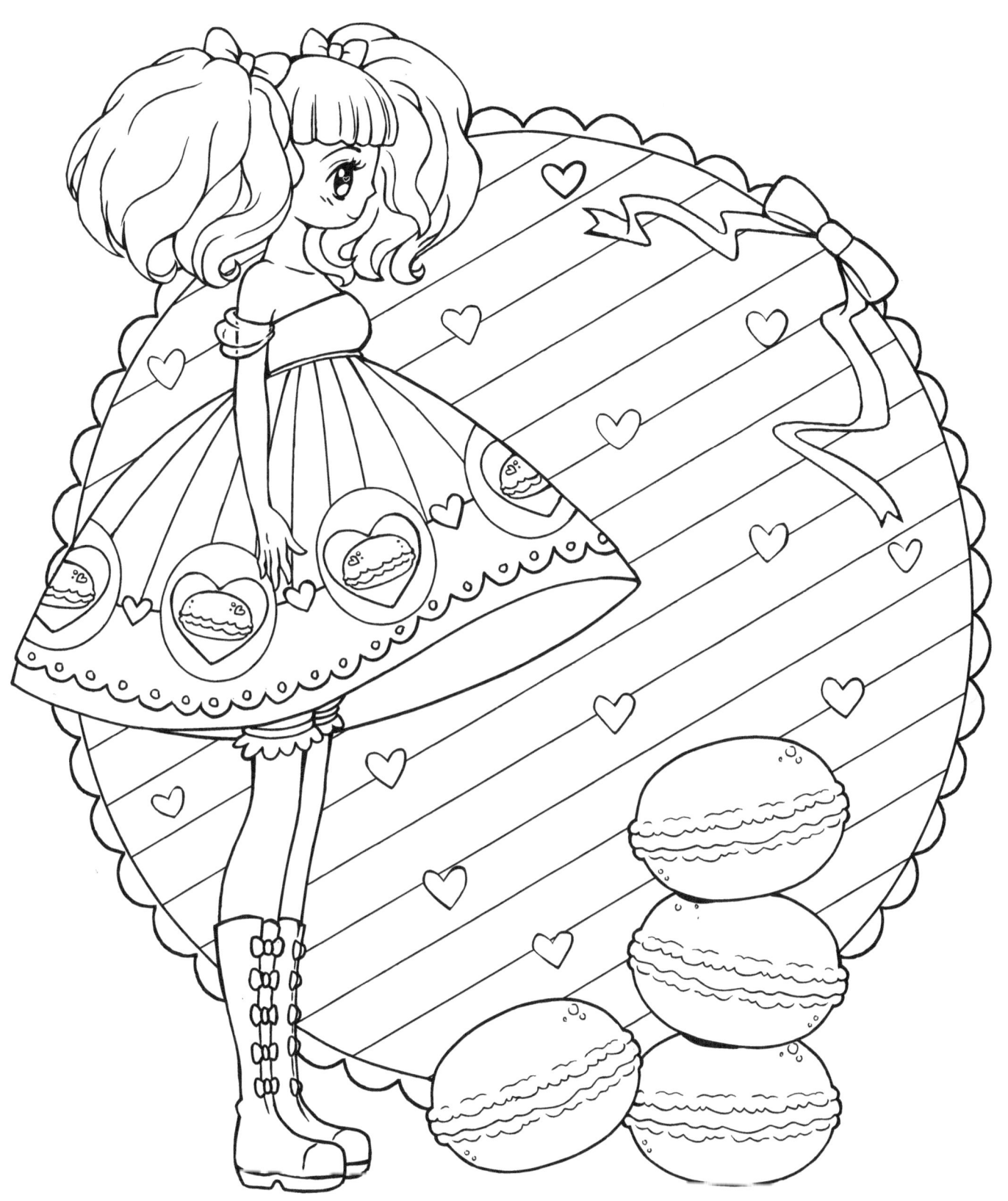

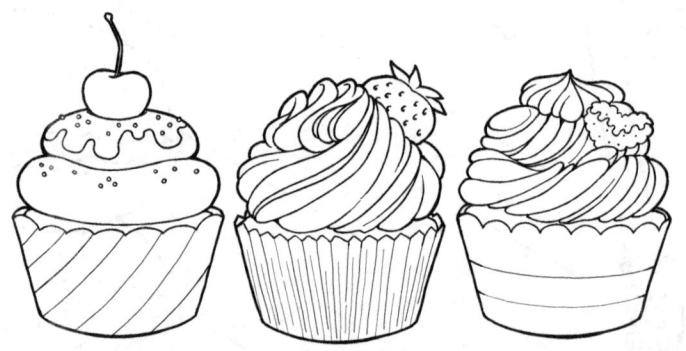

Sweet Macaron Lolita

At some point I was wondering if I had included too many macaron-themed illustrations, but then I figured you can never have too many macarons!

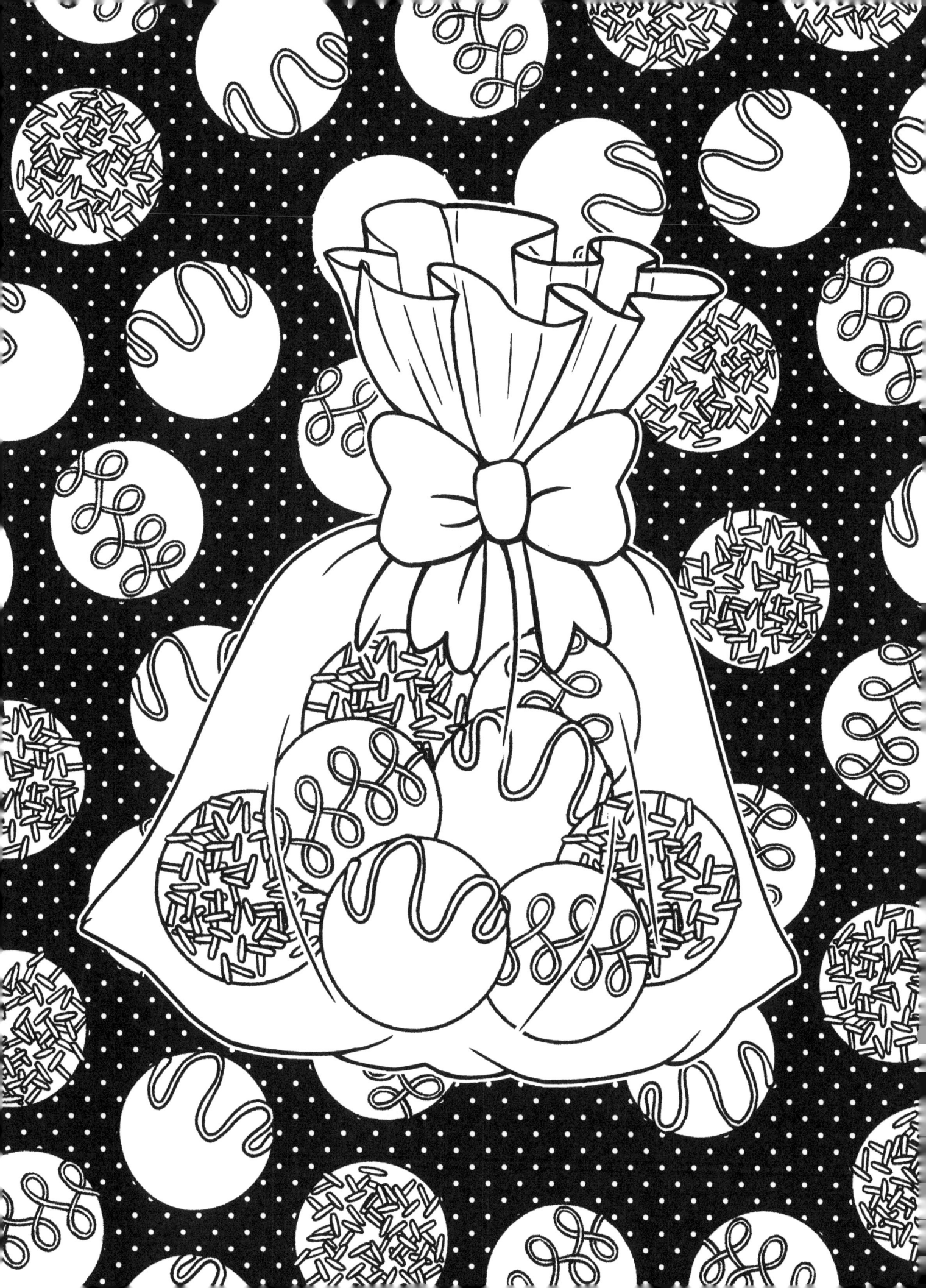

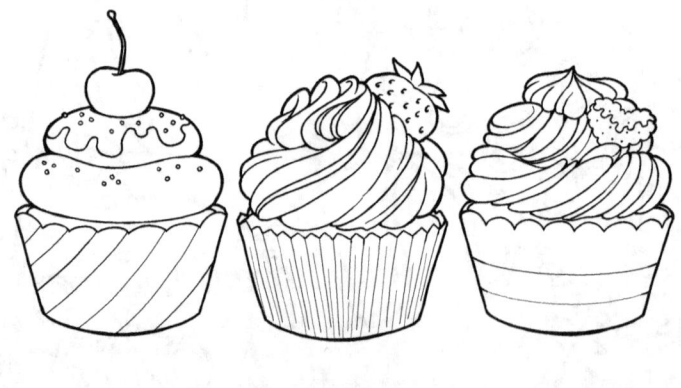

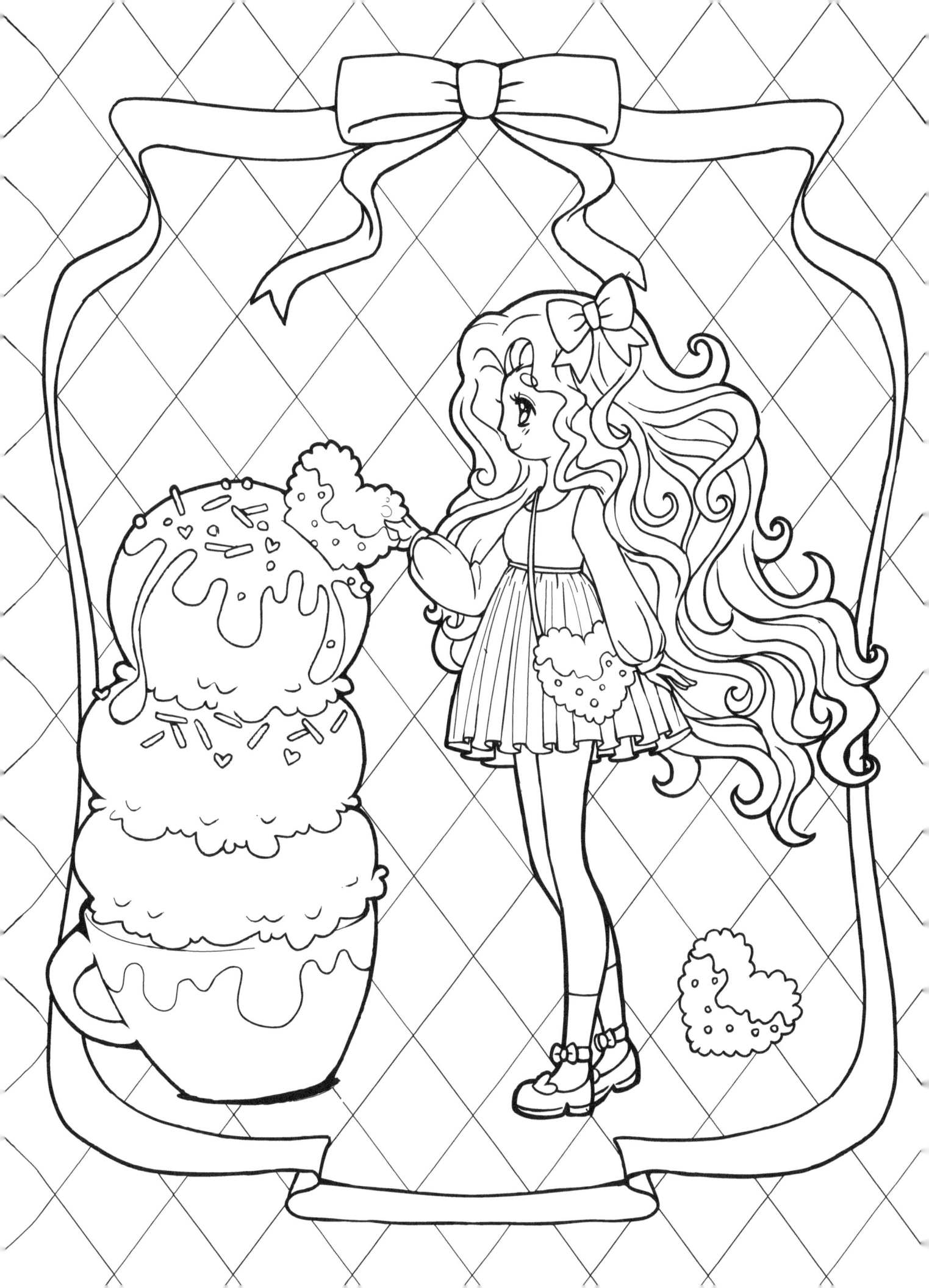

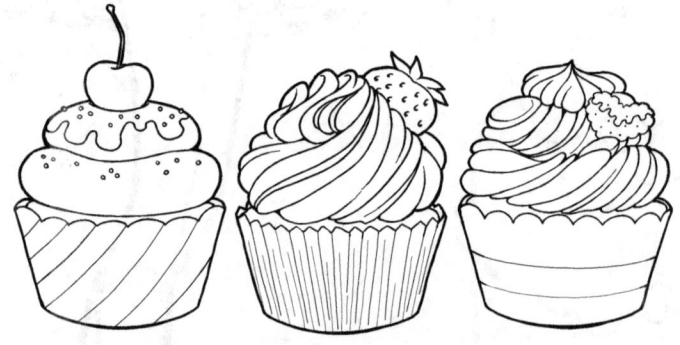

Three Scoops Deluxe

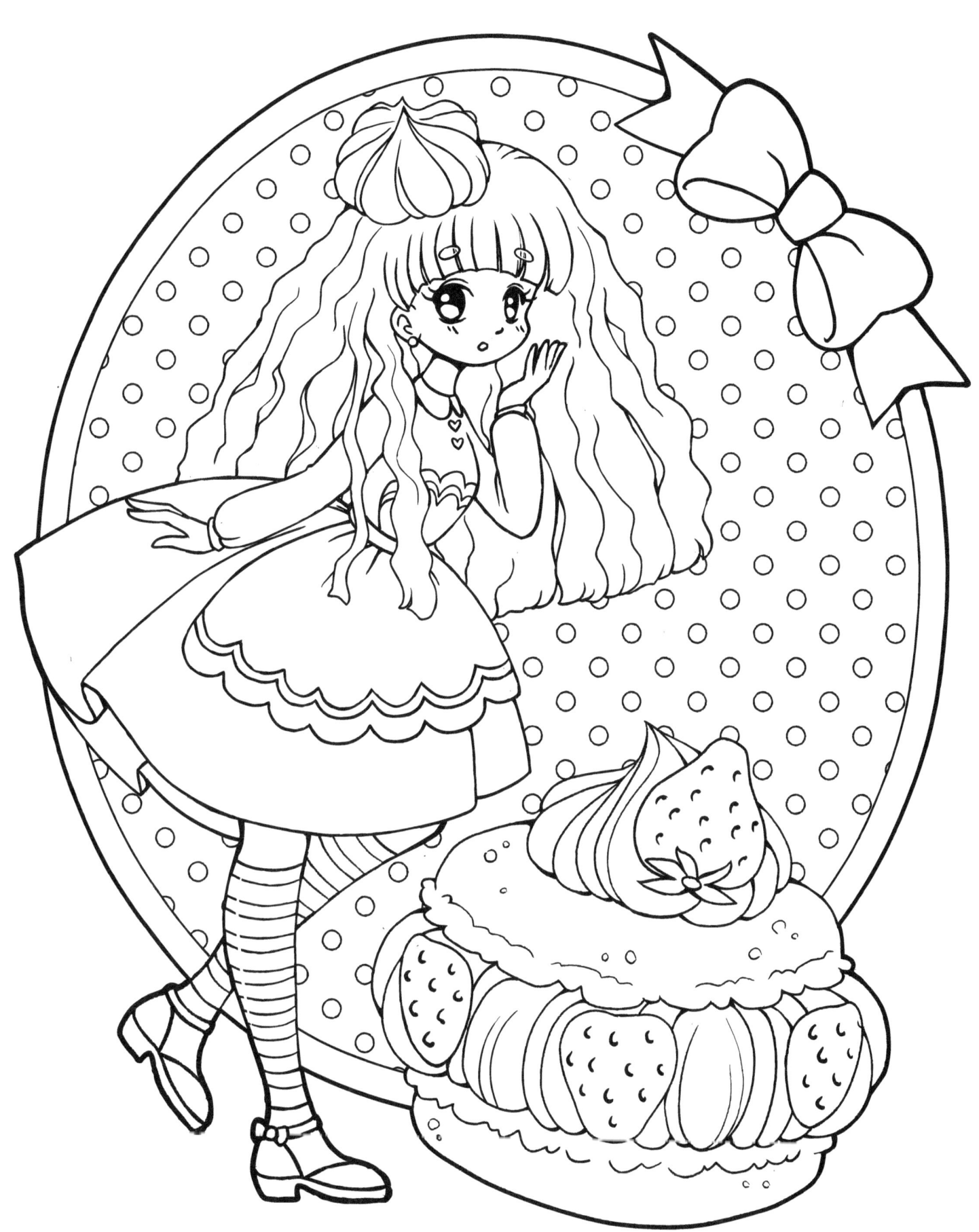

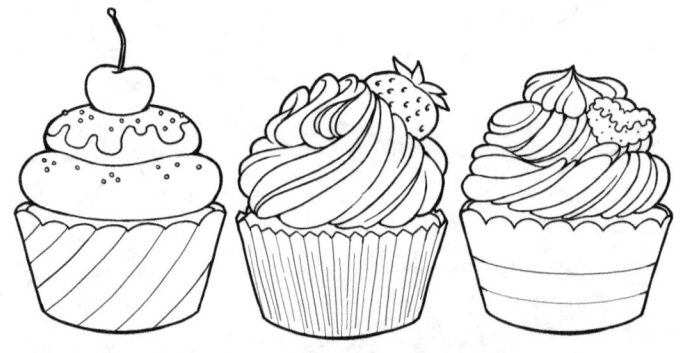

Strawberry Macaron

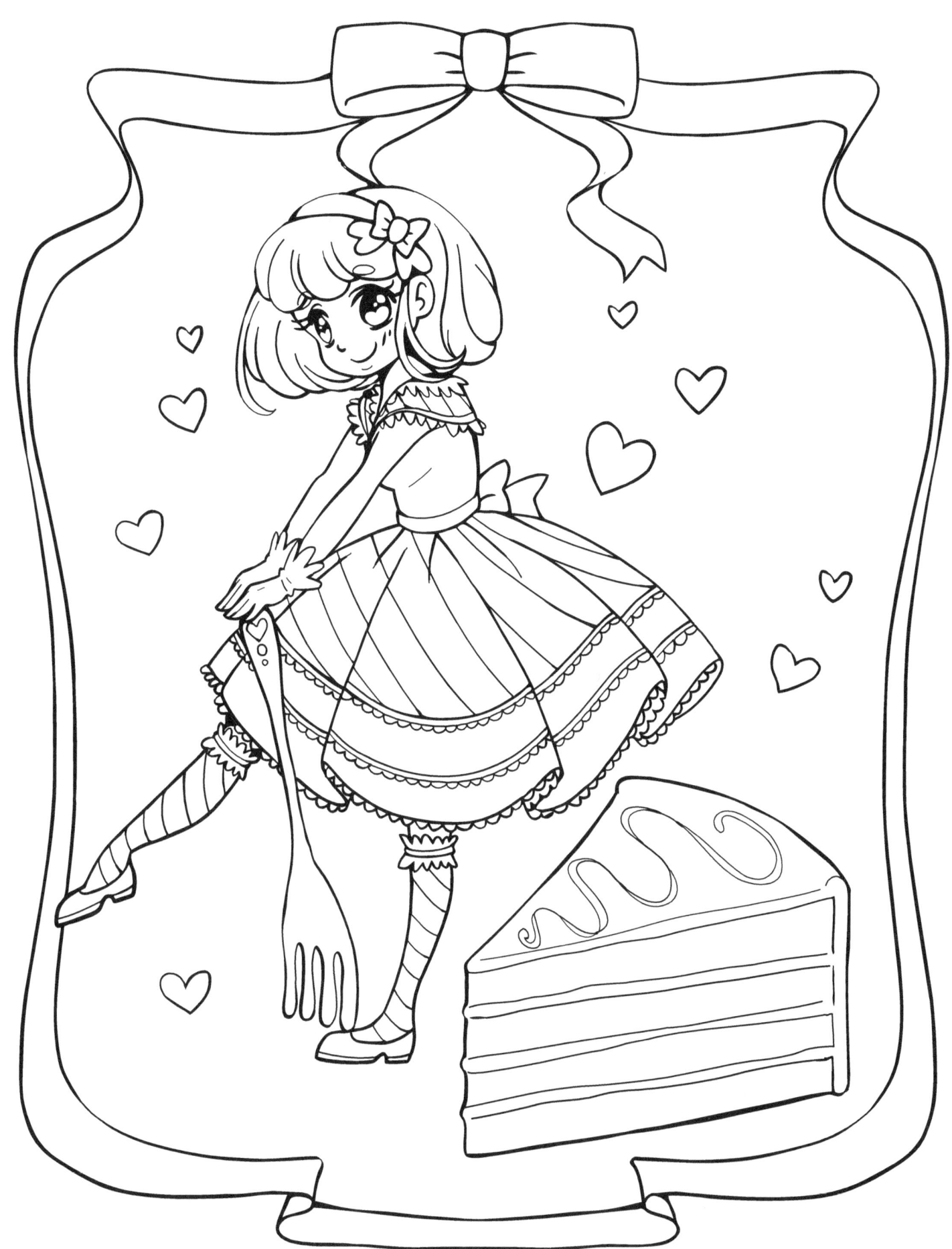

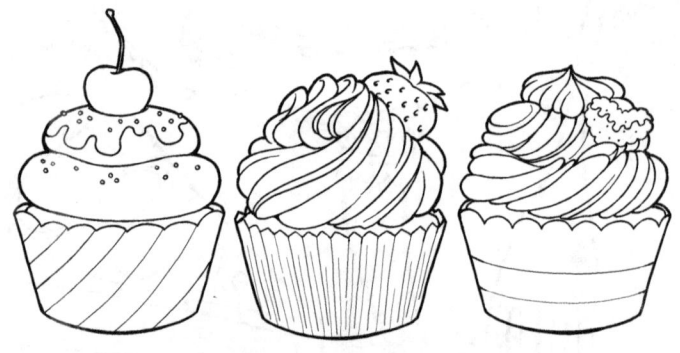

Let Them Eat Cake

The works of Kirai Imai were very influential in the creation of Sugary Dreams! She is simply the master of lolita artwork! I am always inspired by her.

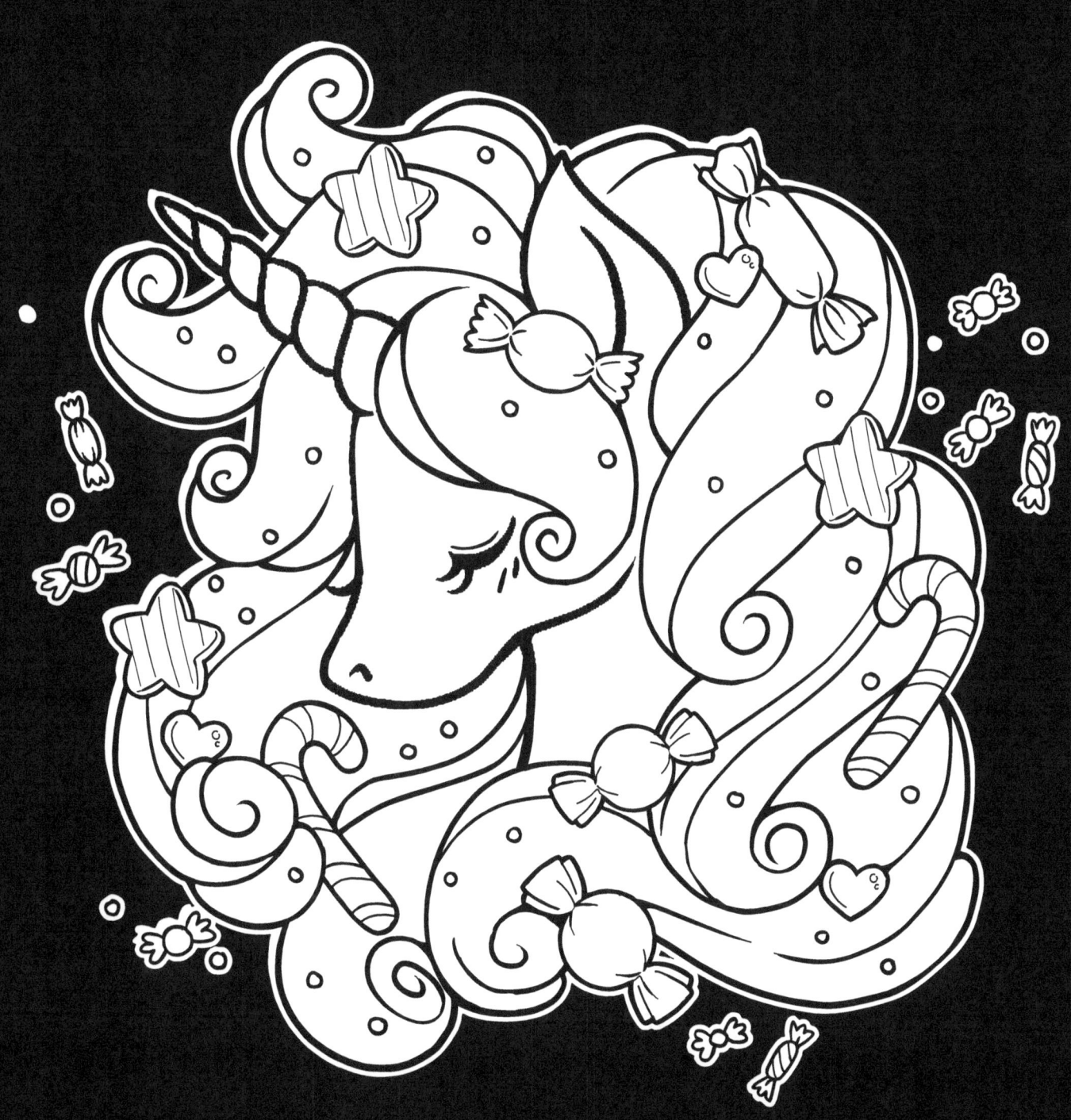

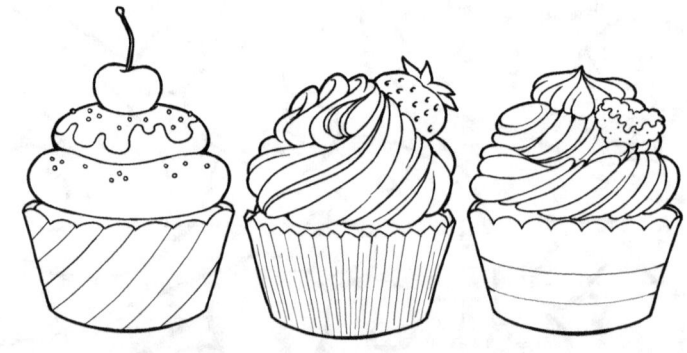

The Magnificent Candicorn

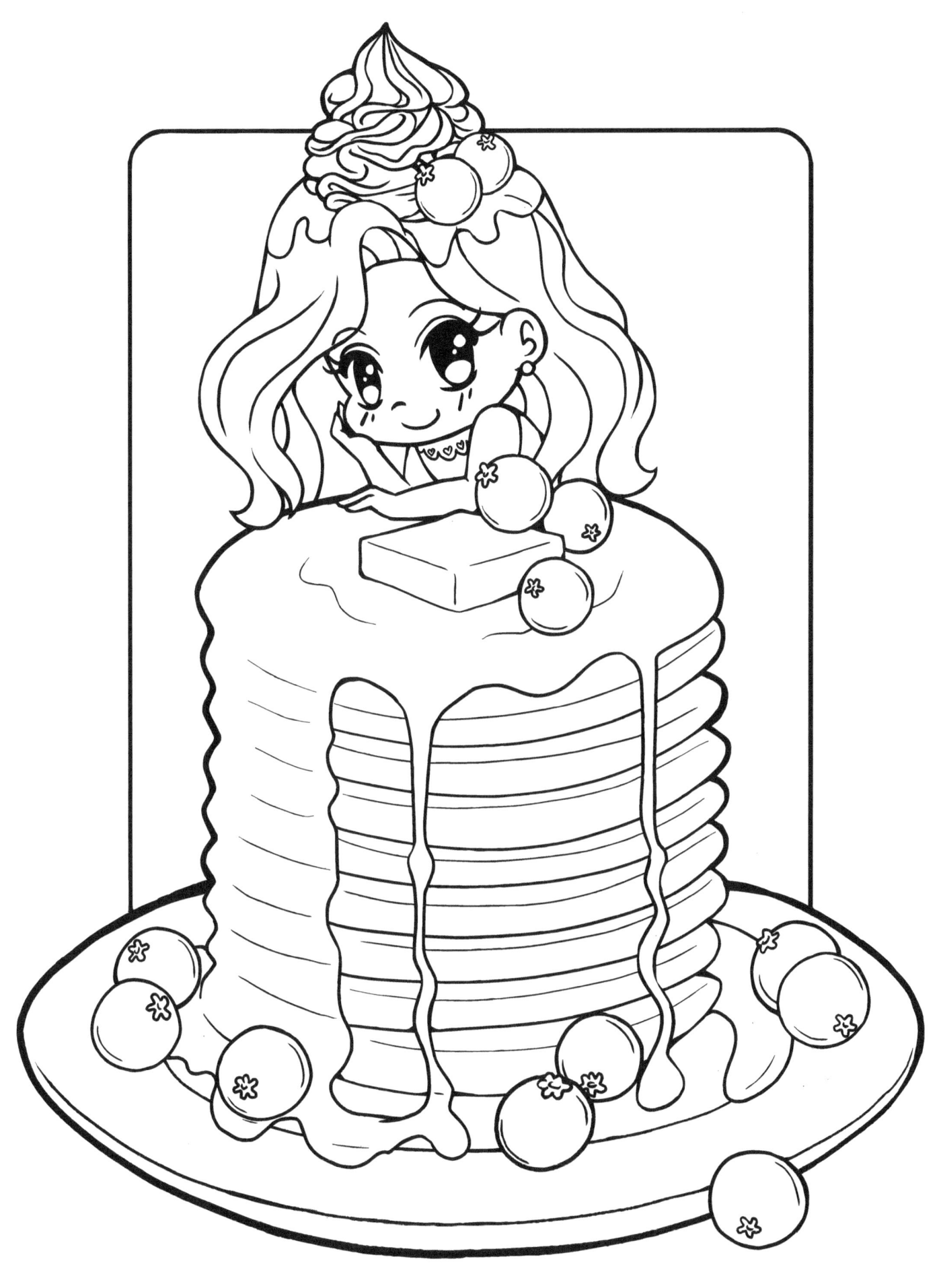

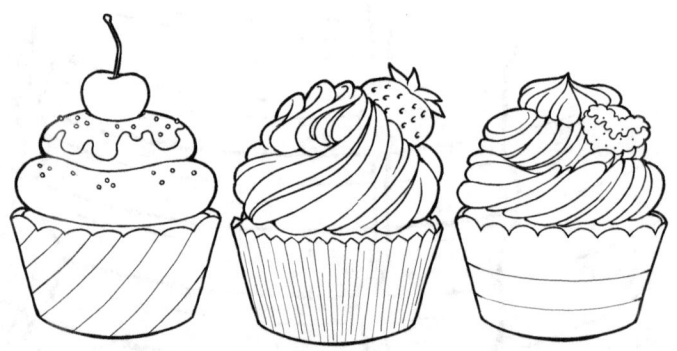

Blueberry Pancakes

I've drawn a few pancake chibis before so the challenge for me was to come up with a new sort of look. She looks happy with her giant stack of buttery pancakes!

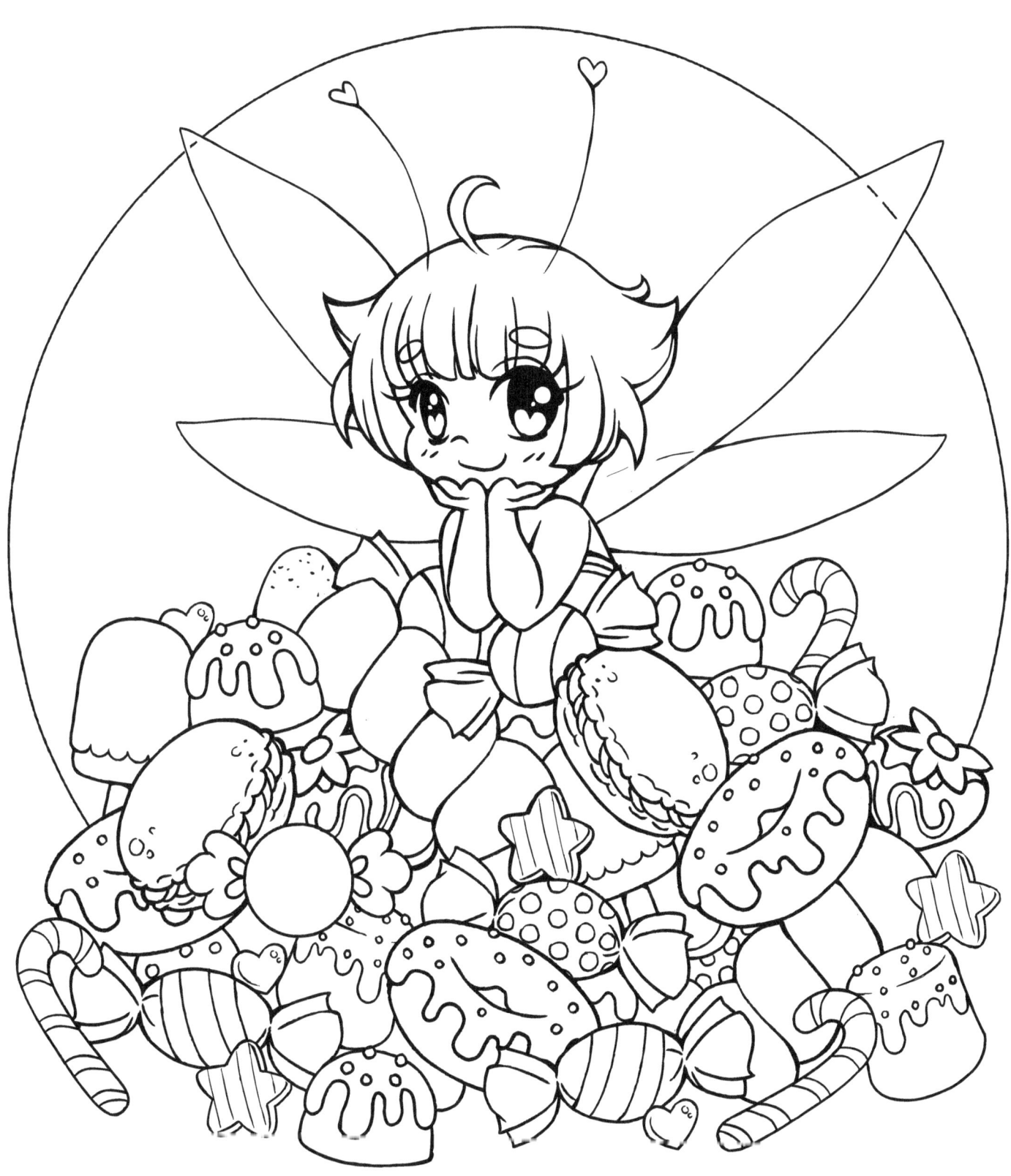

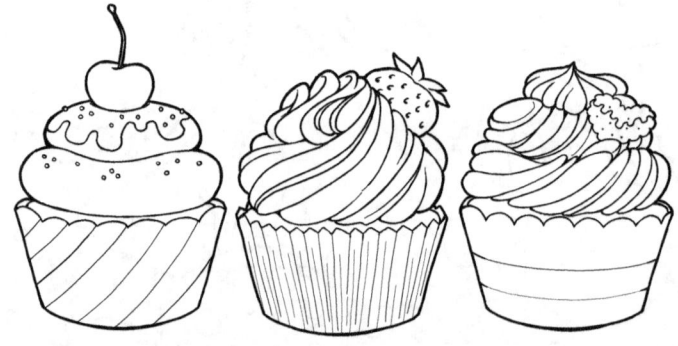

Candy Faerie

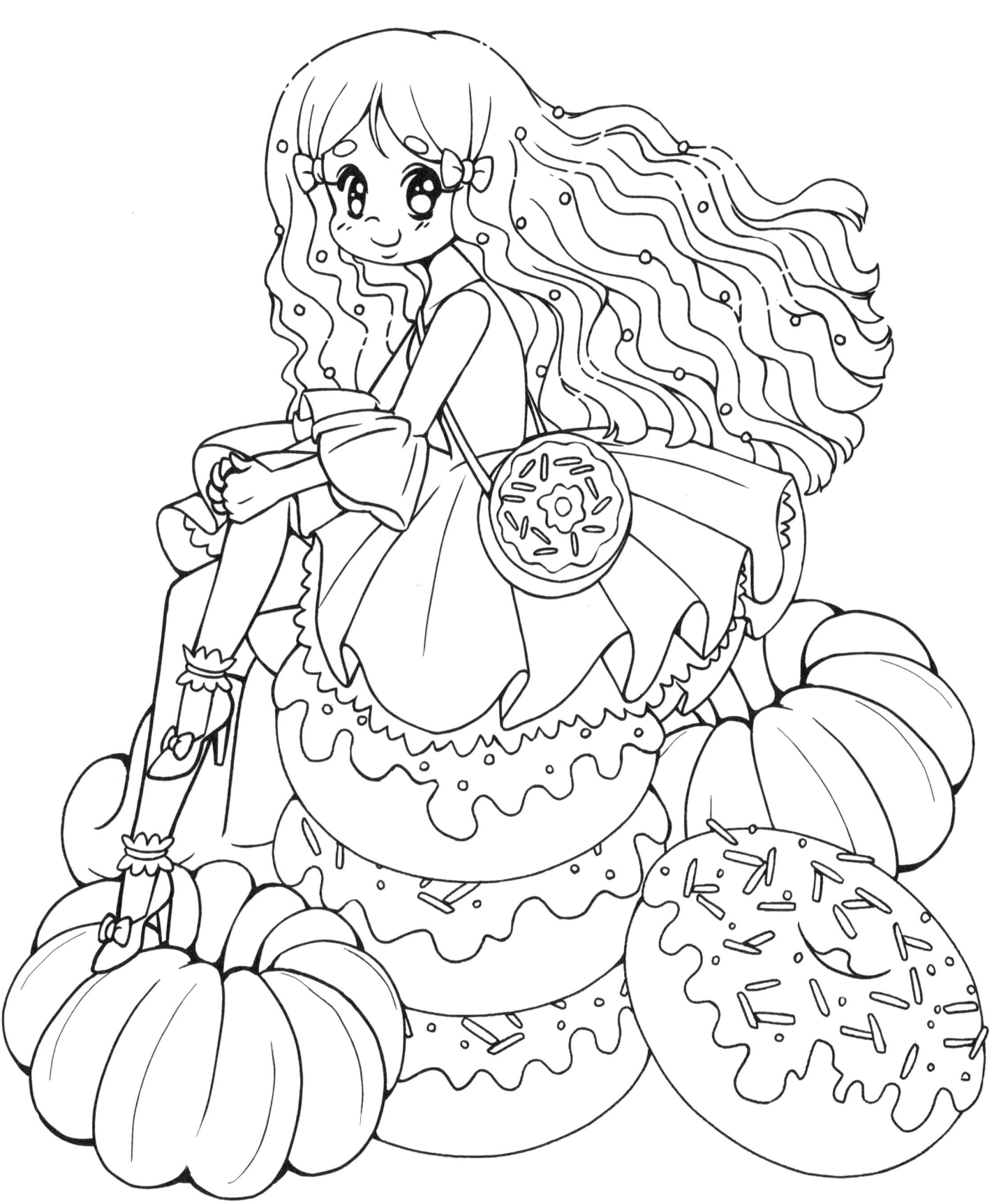

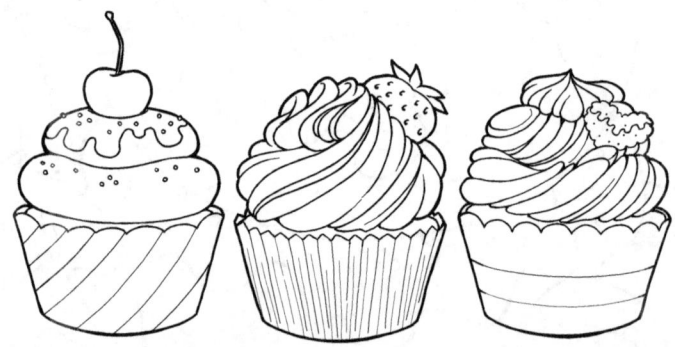

The Donut Princess

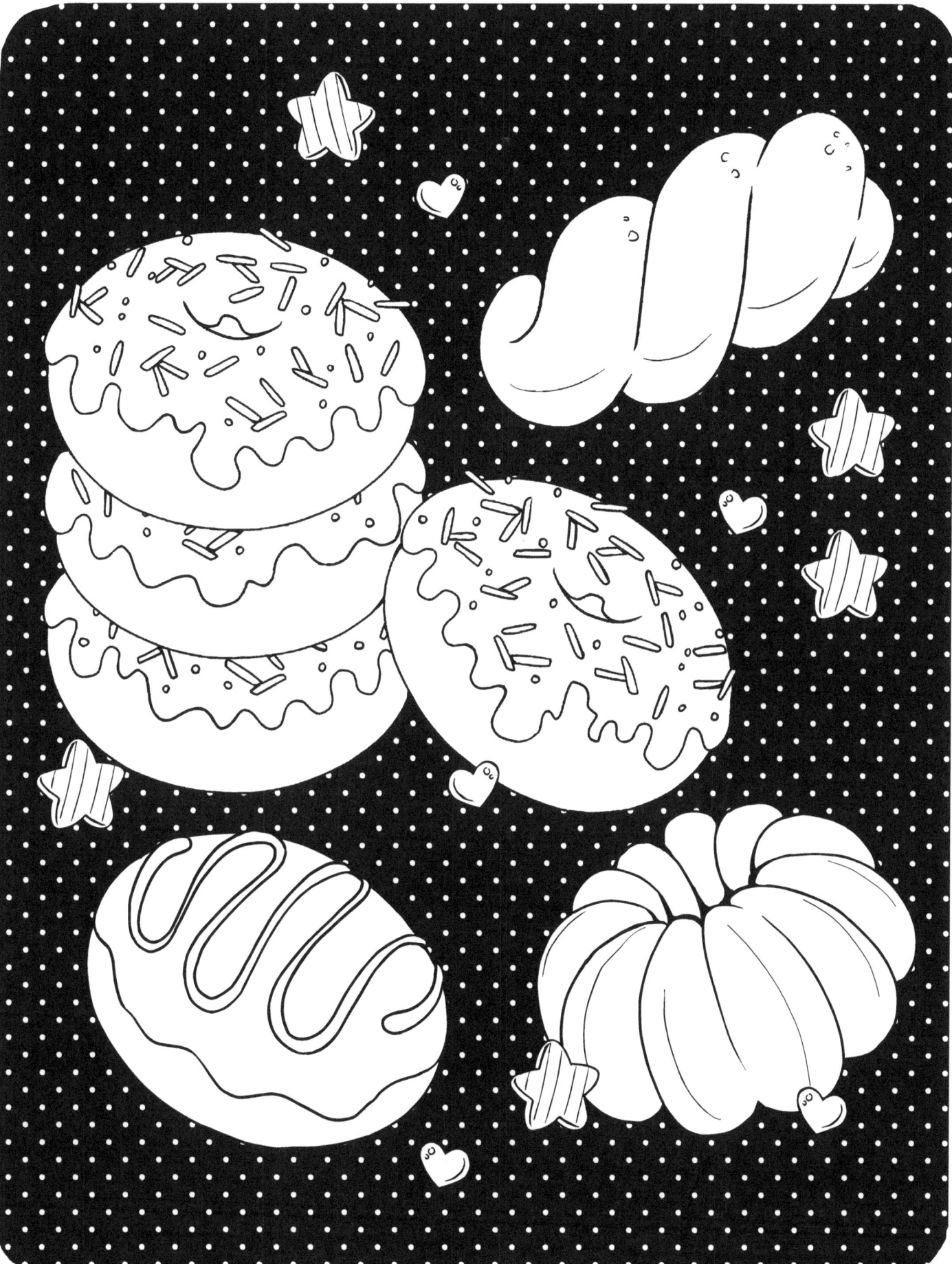

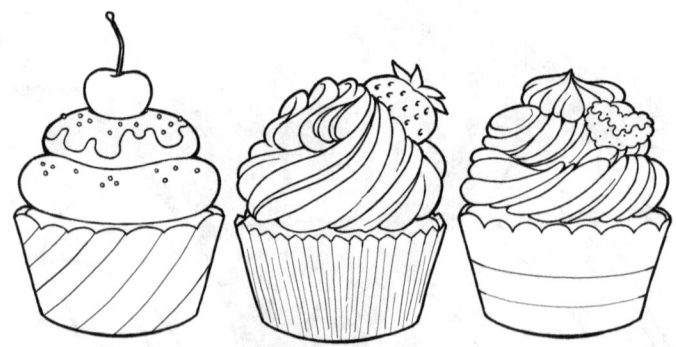

A Delectable Selection of Donuts

What's your favorite kind of donut? I like Bostom Creams.

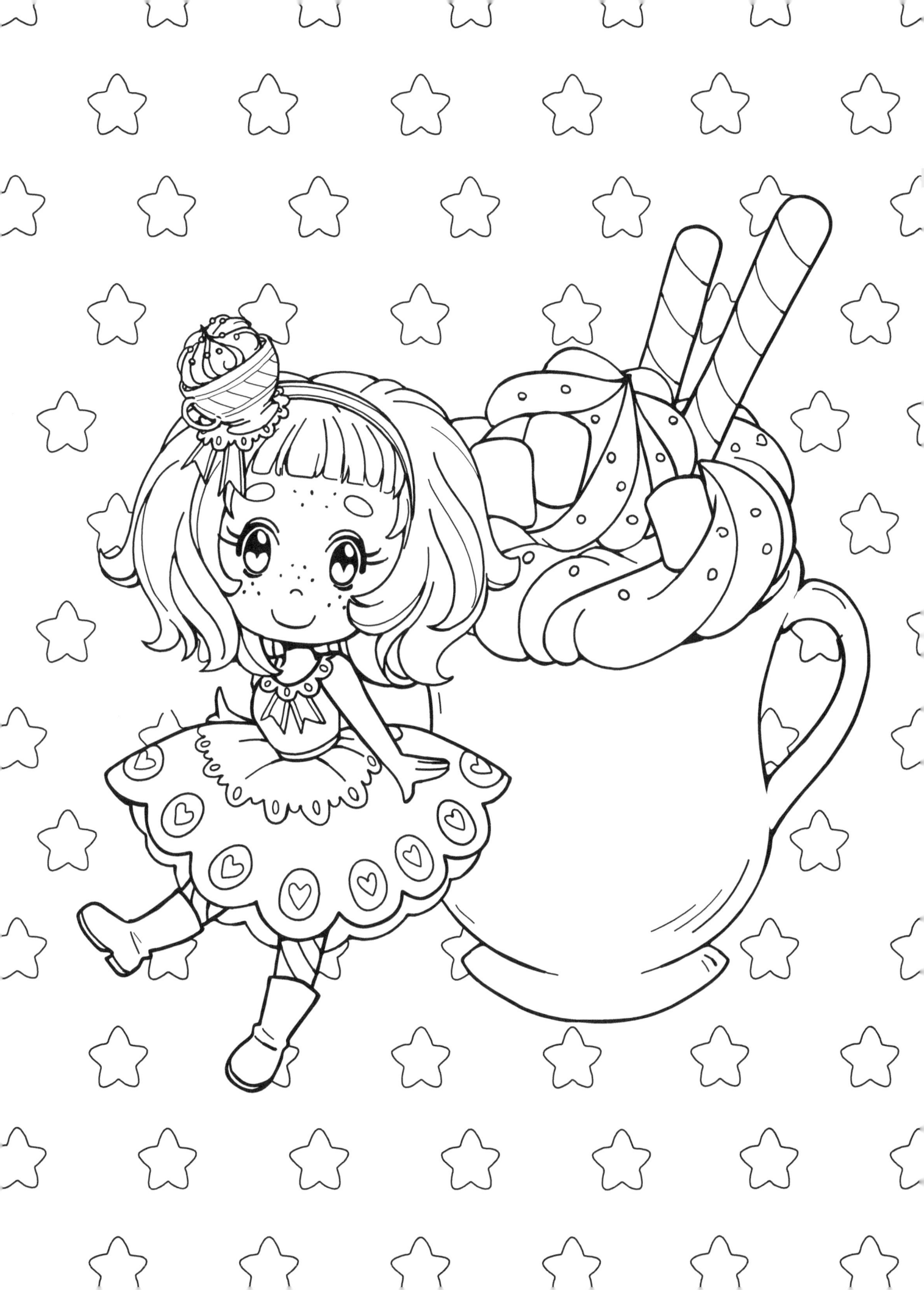

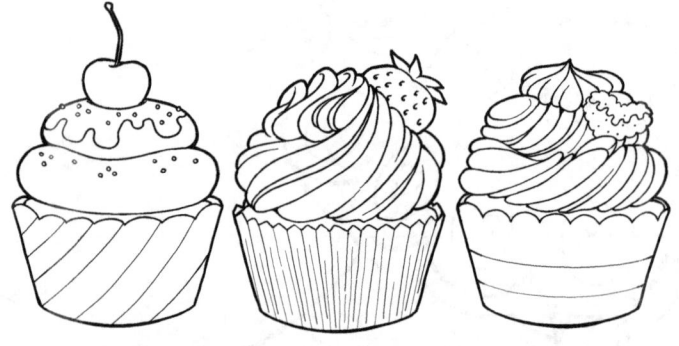

Hot Chocolate Sprite

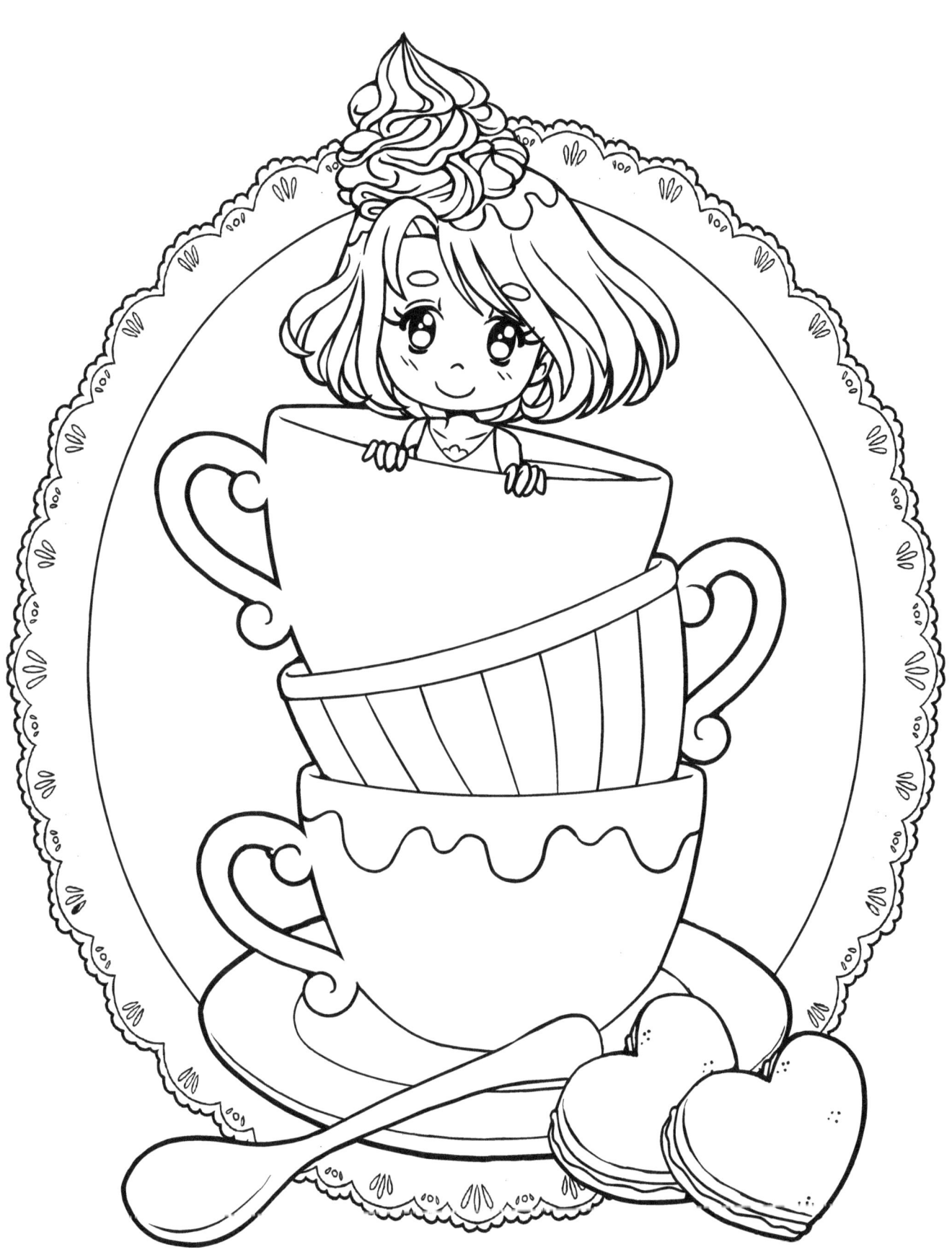

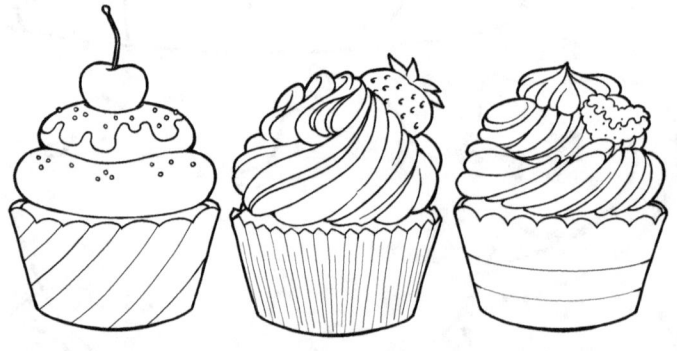

Teacup Sprite

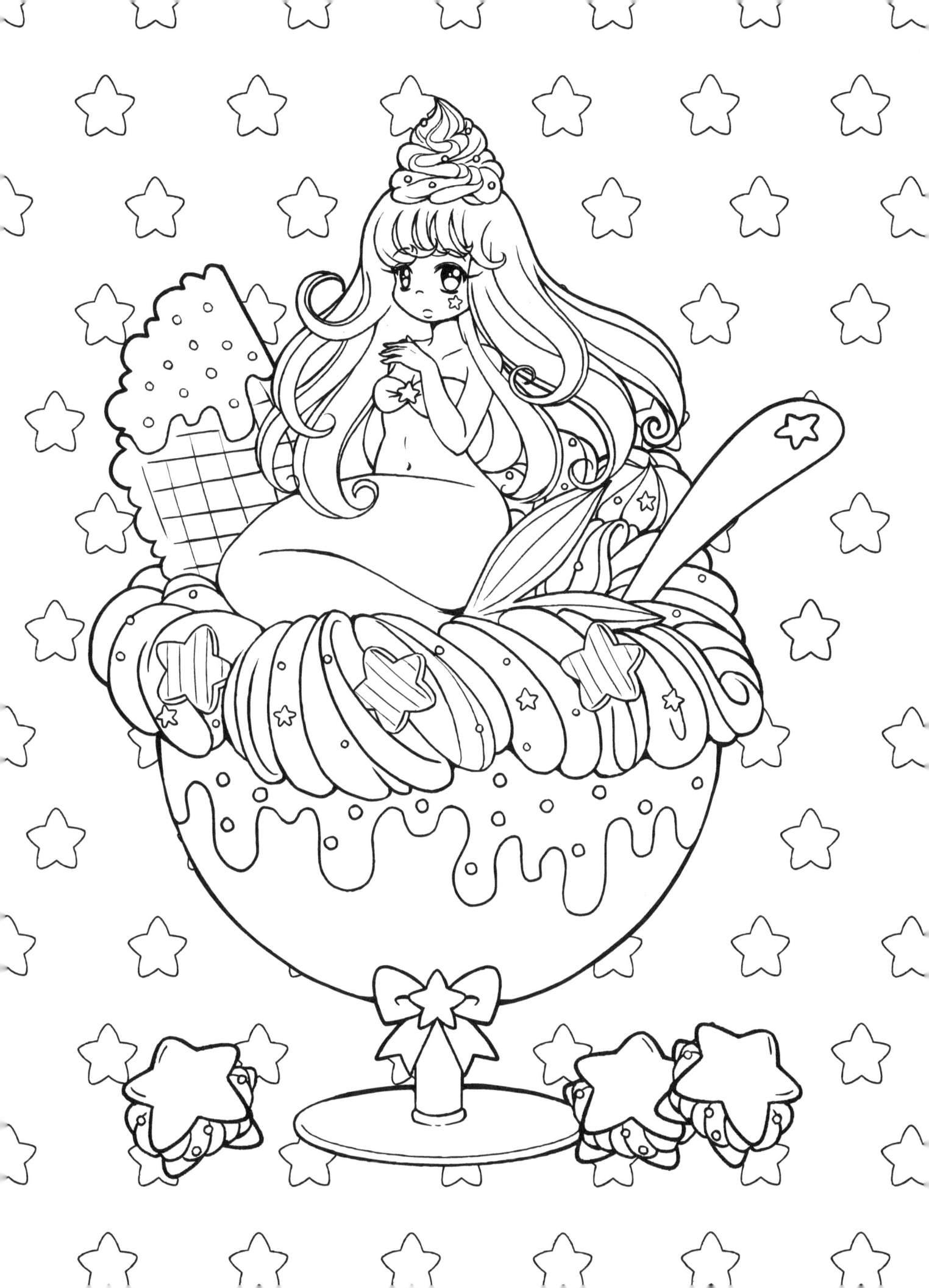

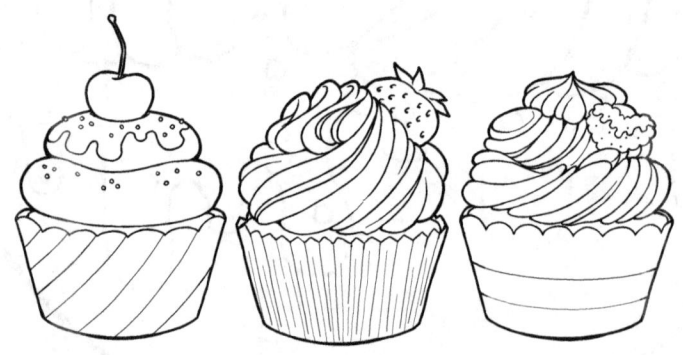

Mermaid Sundae

I just love drawing mermaids - I figured an ice cream sundae would be the best way to incorporate one into Sugary Dreams!

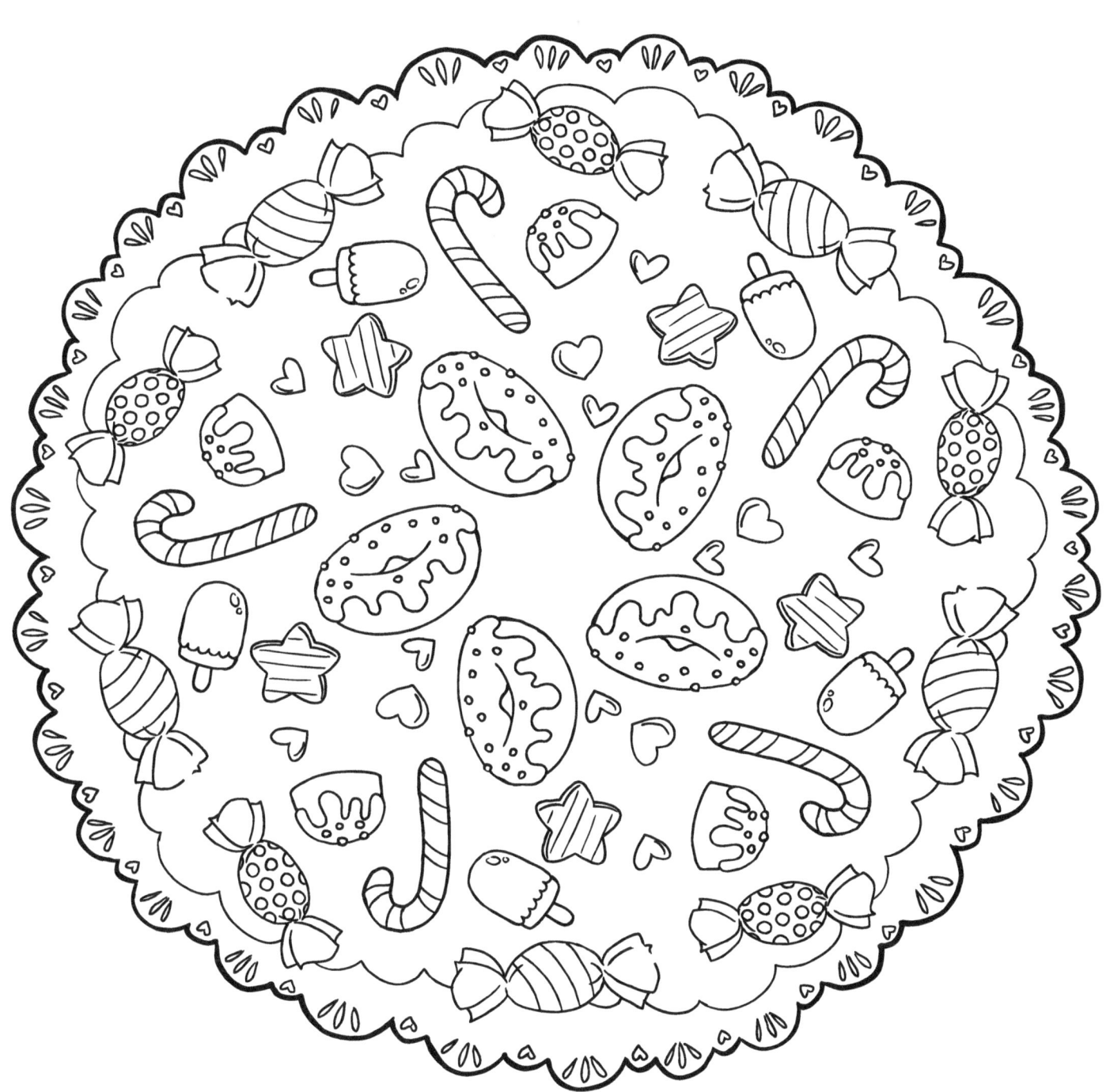

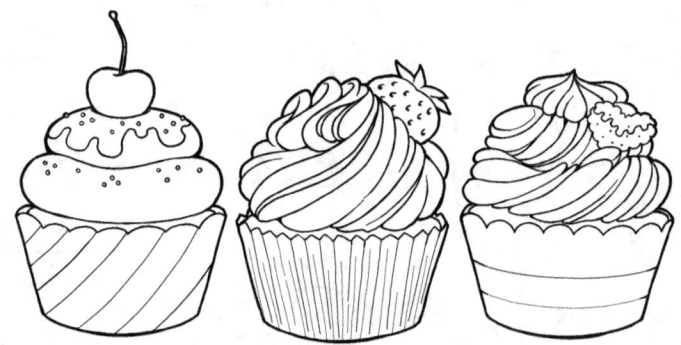

Sweet Mandala

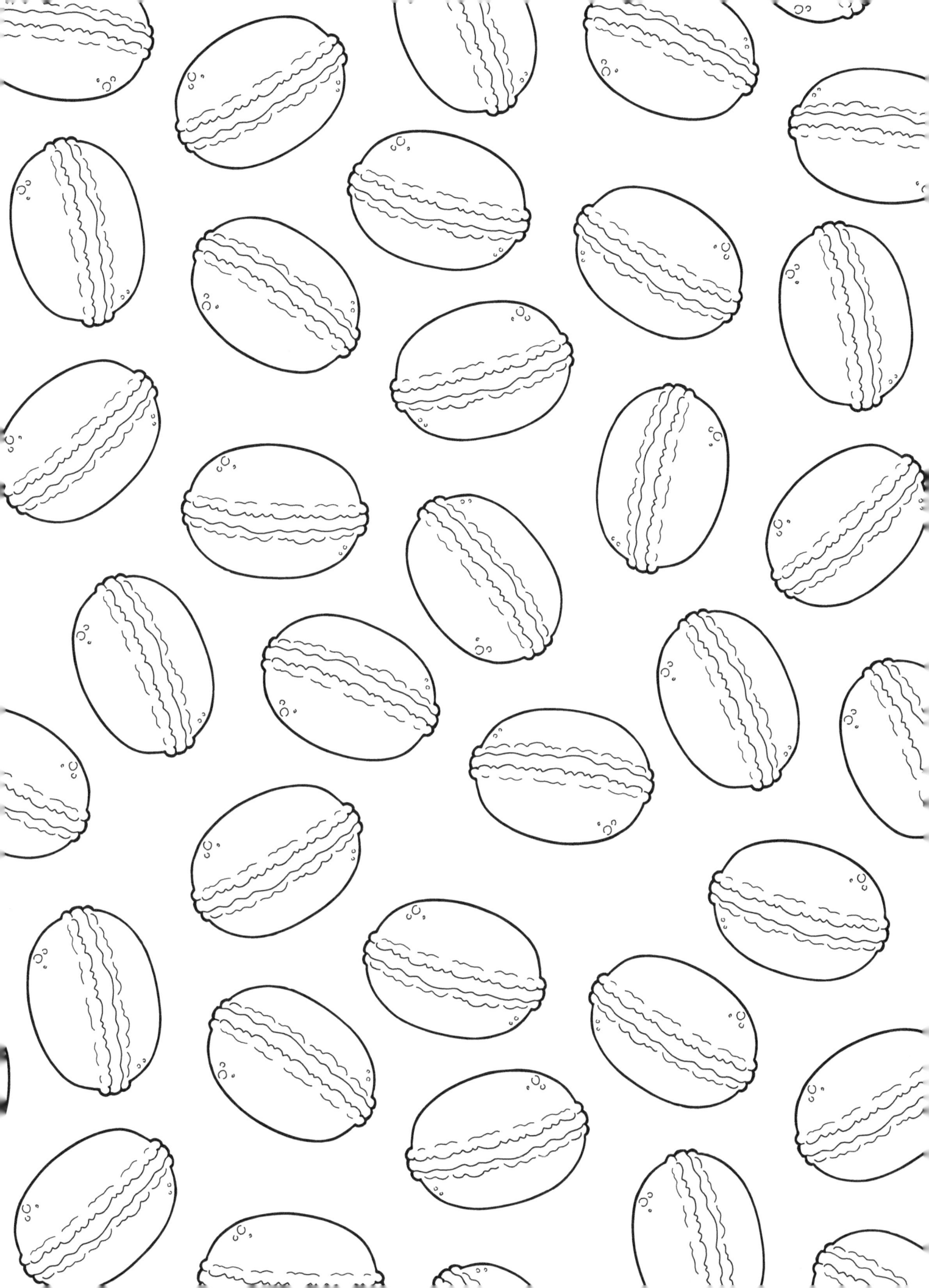

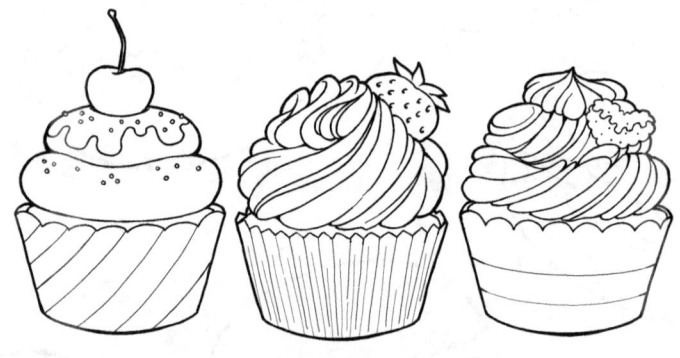

Macaron Madness

Bonus Short Story

Sweet Planet

Scan this QR code

or go to https://www.youtube.com/watch?v=tzp8zQ7GOyk

to listen to the background music for this story!

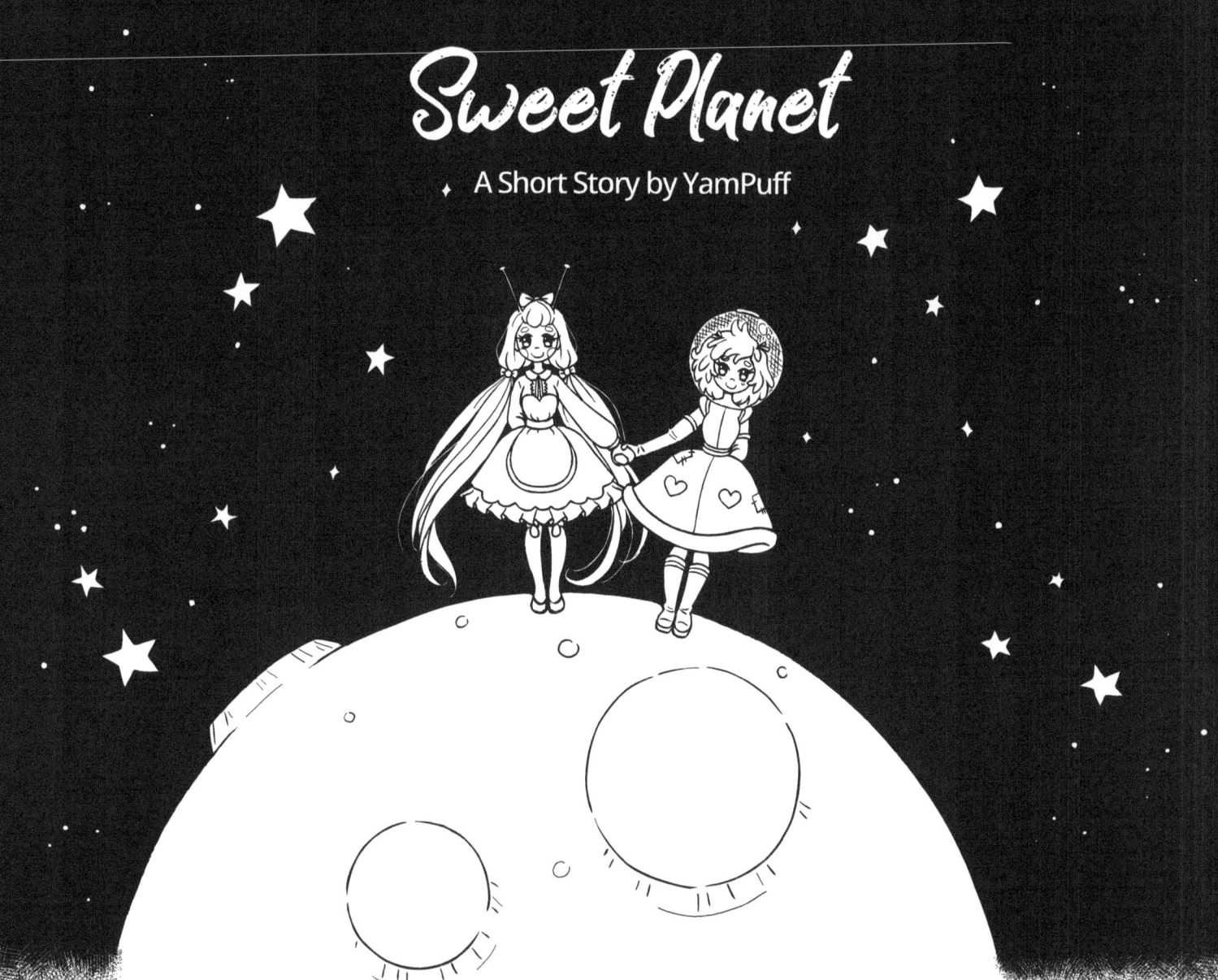

Sweet Planet

A Short Story by YamPuff

On a tiny planet in a faraway galaxy lived a lonely android.

The universe had long ago moved on, leaving her planet behind. On the surface, only she and her android kindred were left. Some androids had lasted longer than others. The absence of the sentient beings that had created them was reason enough for many of them to cease functioning. For others, their mechanical lives went on as normal. As the years went by on that abandoned planet, the cities slowly fell into ruin, as the androids, one after the other, slowly gave up, or broke down, or simply found no reason to keep going. They all fell still eventually.

Reign was the name of the last working android. She lived in a castle on the abandoned planet, in an abandoned city. When the planet had been inhabited she had been a culinary artist, a master pastry chef. She still was, only there was no longer anyone around to eat what she created. But she still kept her kitchens running anyway. It was what she loved to do.

Love, as you can imagine, is not a word used by androids, or in relation to androids very much. It is just not in their programming. Still, living among sentient beings has its side-effects and androids have been known to start mimicking emotions and feelings. And there comes a time when it stops being mimicry.

Reign may have been one of those. Was it pride she felt when she beheld her perfectly flaking crusts and glistening candies? Was it joy that filled her when she frosted her cakes and filled her unparalleled choux pastry with cream? Did sadness cross her thoughts when, at the end of each day, she cleared away those uneaten treasures, things she herself could never eat, nor taste? Was worry an alien concept to her mind at the dwindling supplies the planet could offer, the depleting flour and cream in the ancient storerooms? The slowly fading energy sources that powered the electronic cooling devices? Or did she just move at the command of her programming? Who could know, besides Reign herself? But we do know that now and again she dusted the shoulders and laps of her old android companions, now still and unmoving, though it had never been in her programming to do so.

One day, an alien visited Reign's lonely planet, a human from far away star system. She was a space traveller, and a runaway, and an adventurer. Her name was Taniel.

She landed on the lonely planet in her spaceship and began her expedition. Exploring had always been in her nature, ran in her blood. And since she was a human and her brain did not run on zeroes and ones, and blood ran through her veins rather than electrical currents through copper wires, we do not doubt her passion and love for exploration as we might an android.

There was much to see in the abandoned city but it was clear that the planet had not seen sentient life in many years. Taniel began to find it unbearably lonely. And she found it exceedingly sad when she examined the silent, unmoving androids and discovered they were still in good working order, only lacking the will to continue functioning without purpose.

"Poor things," she whispered and there were tears in her eyes. The androids did not respond. They had never shed any tears themselves. They likely had never expected tears to be shed on their behalf.

She nearly departed the planet then and there. But something kept her from going. She wasn't about to leave this lonely world unexplored. It deserved better than that, from the universe, and from her

So on she went. Then, the unexpected: a delicious, delectable smell. Her mouth watered. She licked her lips. How was it possible? Where was it coming from?

She followed the delicious scent, down a path, around a corner and beheld a magnificent castle, fallen to ruin, half devoured by vines sporting strange purple flowers which bloomed wherever they could.

She went inside.

Everywhere were silent, sleeping androids. She searched for the source of the beautiful smell but the castle seemed devoid of any life. Then, she heard a sound. The scraping of feet on the floor. Someone was near - still alive! Her heart beat faster. She ran to the door, opening it, a smile on her face.

The smile froze. It was only an android.

"Oh," Taniel sad. An android who had continued to function as programmed. She sighed. It was somehow sadder than the others that had given up.

"Why do you keep on, when everything has moved on without you?" she asked.

"Oh!" said the android. "Hello! I have been alone for so long. Would you like to stay for a while, and eat?" The android smiled.

"Why," said Taniel again, in a louder voice, "do you keep on baking? No one is here. What is the point?"

"I hadn't thought of that," mused the android. She tilted her head to one side, as if in thought. "It makes me happy, I suppose. What is your name?"

"Taniel. Do you have a name?"

"Yes; Reign. Won't you stay?"

"Reign," said Taniel, thoughtfully. "Well, yes, I will stay. And eat."

So she sat in the tidy kitchen of the abandoned castle and watched Reign the android bake. She prepared for Taniel a feast of the sweetest things, dripping with honey and milk and sugar. As she baked she talked to Taniel and told her stories of Before. When the planet had been full of noise and life. She told Taniel about the Last Prince who had given up his title for love and abdicated the throne. The wise council that had taken over and had brought great wealth and strength to their planet. The music museums where one could listen to the most beautiful melodies ever composed. And the food! She spoke of the great culinary masters of old, the great Cooking Schools. The competitions - the feast days! She did not mention the end, however. How the planet fell to emptiness and ruin. Maybe she did not know. Perhaps she had chosen to forget.

Taniel sat by the counter, her chin in her hands, and she soon forgot she was on an uninhabited planet. She saw the colorful people that had lived and danced here. She remembered why she traveled. Why she explored.

And when the feast was ready and she ate what Reign had made for her - she forgot entirely that a few moments before she had felt sad and lonely.

"Would you show this planet to me?" she asked of Reign the android.

And though it was not in her programming to do so, Reign agreed. For the first time in many years, her kitchen was left empty, the fires unlit, as she took Taniel around her small planet. They saw many wonderful sights together. Old fountains, great lakes, magnificent crumbling towers. The creeping vines with the purple blossoms were everywhere, absorbing the artificial structures into the planet. One day, thought Taniel, you might land on this planet and think it had never been inhabited at all. It was a sad thought.

When Taniel began to feel the urge to leave this planet and explore others (as she always did, eventually) she wondered what she should do about Reign. When they returned to Reign's kitchen, she had a wonderful idea.

"You should come with me, Reign," she said. "We could explore the universe together."

Reign shook her head. "This is my home," she said. "This is my planet. My kindred sleep here. I could never leave."

"They're just androids," said Taniel. "You are just an android. What is the point of staying her and cooking for no one?"

Reign was silent. Taniel did not notice the sadness in her eyes.

Taniel went on. "You are wasting dwindling supplies only to throw what you make away! There is no purpose to your existence here! Can't you see?"

Reign's sadness deepened. "You are right," she said. She sat down, drew up her knees to her chin, and closed her eyes.

Taniel tried to wake her, but she would not budge. She called her name, and cried. But Reign remained asleep. At last, Taniel dried her tears and went back to her spaceship. She realized she had made a terrible mistake. Taniel did not know how - or even if - she could ever atone for it.

So she thought about Reign and what had made her happy. How she had wanted to stay on her planet. Then, she had an idea. And this time, it really was a wonderful idea.

Taniel got into her spaceship and began to travel. She was not exploring, however. She was going back, to places she had visited before, to people she had met and helped and inspired. She told them about the abandoned planet. She told them of the sleeping androids. And most of all she told them of the little android that had never stopped doing what she loved the most. Even though there was no reason for doing it besides joy. She told them about the ruins and the magnificent, crumbling castle and the sights to be seen on that world.

They joined her. They wanted to see that planet, that world. Their curiosity was piqued, their interest touched. Word spread and others learned the coordinates of the tiny planet where one lonely android had never given up.

Taniel never told them about what had truly happened. That because of her Reign had given up. She prayed that what she did would be enough, for Reign's sake.

She brought them to the abandoned planet and led them down the empty streets and crumbling ruins. She walked with the visitors - other aliens, like herself - through the magnificent castle and to the kitchens. She opened the doors and led them inside. The lights were still off. Inside was only silence. Tears came to her eyes, but she did not, would not give up.

To the visitors, Reign was no more than another one of the many silent, sleeping androids they had passed on their way. But she was more than that to Taniel. She had eaten her food, explored the city with her, and listened to her stories. And now she was asleep.

The visitors explored the castle, searching for the android that had never given up, not knowing she was right there. Taniel sat by Reign and held her hand. And she spoke words of apology. But Reign did not move. At last, moved to tears, she hugged Reign tightly and cried. "Won't you fill this kitchen with light again?" she sobbed. "We so wanted you to cook for us."

By this time the visitors had realized that the last lonely android had given up on this sad planet as well. They watched in sadness as Taniel cried. Her tears fell in large messy drops on Reign's smooth cheeks. The sad murmur of the disappointed guests fell upon Reign's ears. Her mechanical heart was moved by these things. And then something amazing happened. Reign's eyes fluttered, and then opened.

"Taniel!" she cried. "What's happening? Who are these people?"

"These people have come to see you, and this planet," said Taniel, wiping her eyes dry. "You don't have to leave your beloved planet and you don't have to stop doing what you love. We will help you rebuild this planet again."

Reign smiled and at that moment everyone present forgot she was an android and thus could not feel joy. No one had ever told Reign she couldn't feel those emotions and so she was not aware she shouldn't have been feeling such happiness and love. She just felt.

And so she baked for Taniel and the many visitors. They ate in amazement and delight. When they went back to their homes they told their families and friends about the wonderful abandoned planet. The sweet and lonely planet. And they told Reign's story.

More and more people began to visit her planet. And the more people visited, the more the androids began to stir. One by one, they started their systems and restarted their functions. Some people who visited the sweet planet decided to stay. Others left but often came back to visit.

One of the latter was Taniel. Just as Reign could not bear to leave her planet, Taniel could not bear to stay in one place forever. But she could visit often. And Reign, though filled with happiness at her growing planet and the streams of people who came to visit her kitchens every day, was happiest when Taniel was visiting. And so life on the Sweet Planet went on.

THE END

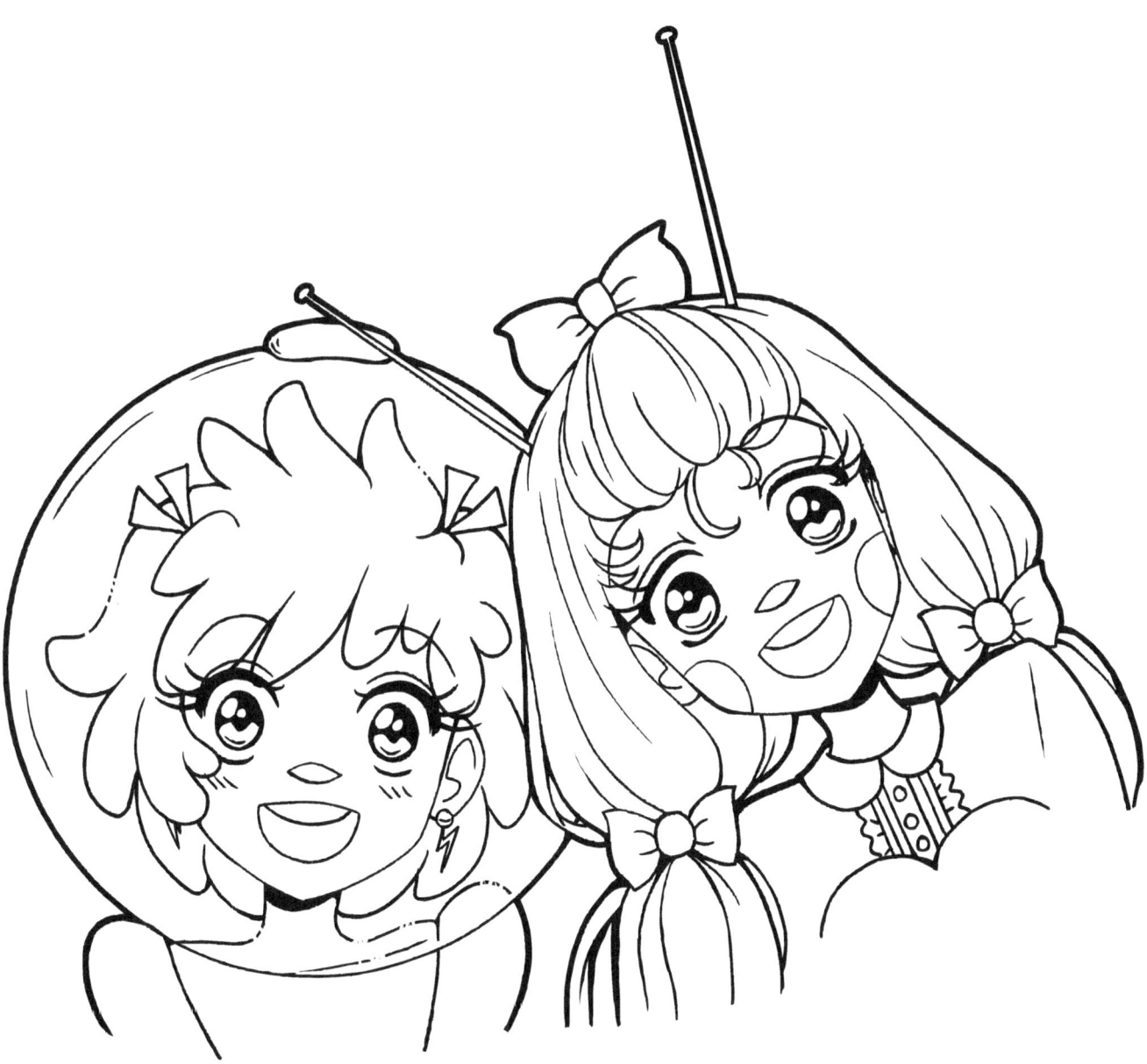

Check out the Color Charts Collection by Yasmeen Eldahan!

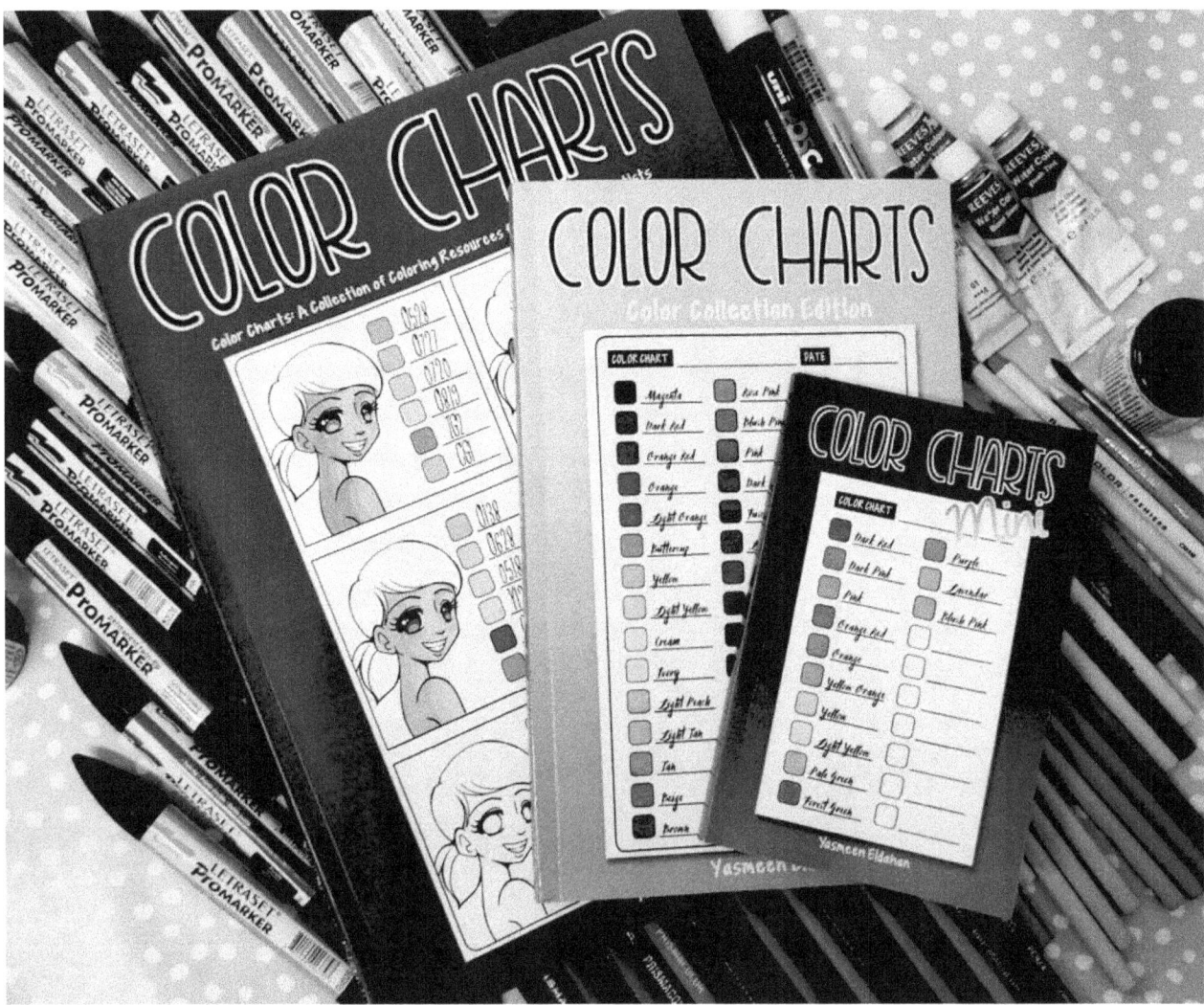

The Color Charts collection has all you need to practice your coloring skills and to record your favorite color combinations. Organize and categorize your art supplies by documenting all the colors you own. Never forget which colors you used to make that perfect shade. Practice coloring skin, hair, eyes, clothes and more! Single-sided pages ensure that any media can be used for coloring without worry. Sharpen your coloring skills with COLOR CHARTS!

For more information, visit yampuff.com!

Carousel Dreams: A Coloring Book by YamPuff

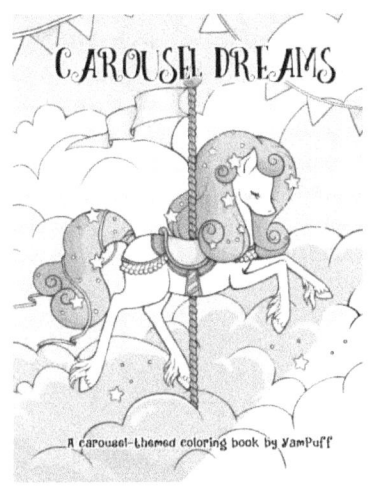

Color in a merry-go-round of adorable, detailed linearts in YamPuff's second coloring book compilation; Carousel Dreams. Consisting of 24 brand-new carousel-themed illustrations - from majestic unicorns to girls in carousel-themed dresses - this coloring book is perfect for carousel lovers of all ages! All illustrations are printed on one side of the page so colorists can use inks, pens or markers without fear of ruining art on the other side! On the other side of each page is a little description of the art and its creation by YamPuff! All linearts in this book are super smooth and crisp, ready and waiting for your colors to bring them to life!

Bonus Sample Page!

www.ingramcontent.com/pod-product-compliance
Lightning Source LLC
Chambersburg PA
CBHW080723190526
45169CB00006B/2489